IMAGES
of America

MOUNT JULIET

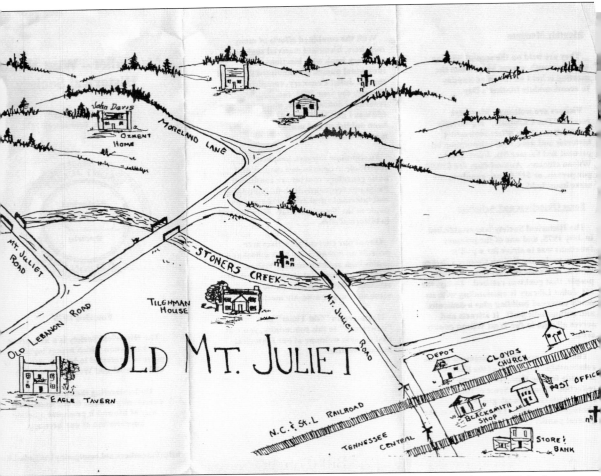

This sketch of Mt. Juliet was drawn by native daughter Madelon Wright Smith in 1975, before more recent development. To the north is the original Mt. Juliet cedar cabin that John Davis owned. To the south is the village hub and its businesses, with the two railways running through the town. (Courtesy West Wilson Historical Society.)

ON THE COVER: The front cover shows Mt. Juliet residents at the turn of the 20th century in front of the old First Baptist Church. Any religious differences were set aside that day, as congregants from a variety of denominations flocked to the church to pose for a photograph. Economic woes prevented many people from purchasing cameras, so when they saw an opportunity to have their photograph taken, they took advantage of it. (Courtesy West Wilson Historical Society.)

IMAGES
of America

MOUNT JULIET

Bill Conger

ARCADIA
PUBLISHING

Published by Arcadia Publishing
Charleston, South Carolina

Printed in the United States of America

Library of Congress Control Number: 2013933923

For all general information, please contact Arcadia Publishing:
Telephone 843-853-2070
Fax 843-853-0044
E-mail sales@arcadiapublishing.com
For customer service and orders:
Toll-Free 1-888-313-2665

Visit us on the Internet at www.arcadiapublishing.com

This book is dedicated to my mother, Susanne Tenpenny, whose creative force gave me the courage and desire to pursue my own dreams.

CONTENTS

Acknowledgments 6

Introduction 7

1. The Early Days of Mt. Juliet 9

2. Hitting the Books and Balls 37

3. All Aboard! 57

4. Faith and Farming 65

5. Simple Living 99

6. Modern-Day Mt. Juliet 113

ACKNOWLEDGMENTS

This pictorial history of Mt. Juliet would not have been possible without the great assistance of the West Wilson Historical Society, in particular Donna Ferrell Graves and Diane Weathers. They provided a wealth of photographs and historical information, backed by years of tireless research. I'd also like to thank the city's first mayor, N.C. Hibbett. His photograph collection is surpassed only by his love of railroads. A native of the town, he delivered intriguing stories about the early days. A tip of the hat also goes to Kayla Conger Boys, who captured modern-day Mt. Juliet with her artistic photographer's eye. My wife, Alyssa Conger, graciously offered her technical computer knowledge and emotional support, and my eight-year-old son, Gavin, willingly shared his daddy time. I want to thank my daughter, Autumn, who I love unconditionally. I remain grateful to editor Liz Gurley at Arcadia Publishing for her infinite patience, support, and help with the project. I also want to thank Nancy Armstrong, Jenny Hibbett and the staff of Mt. Juliet Library; Linda Granstaff and Thomas Partlow at the Wilson County Archives; Charles McCorkle, Linda McCorkle Eakes and Arcadia Publishing's Mike Litchfield for their keen observance in proofing the book; City Manager Kenny Martin; Sgt. Tyler Chandler, community policing director of the Mt. Juliet Police Department; Esther Hockett; Ron Castleman; Charles McCorkle; Murita Hayes; Mark Brewer; and Jim Bell. All images in the work are from the West Wilson Historical Society unless otherwise indicated.

INTRODUCTION

Mt. Juliet is one of the fastest-growing communities in Tennessee. Nearly 400 houses were built here in 2012, and a new business permit is issued every two days. A long string of restaurants and shops stand shoulder to shoulder along a four-lane highway stretching to the eastern pinnacle, the ever-popular Providence shopping area. Located 17 miles east of the Country Music Capital, more than 25,000 residents pack this thriving western Wilson County suburb of Nashville. Mt. Juliet has undergone a remarkable metamorphosis since its humble beginnings 230 years ago, when hunter Michael Stoner pioneered Stoner's Lick Creek. Then, it was part of western North Carolina. Indians hunted on the land until the militia ran them out. In 1800, young adventurers John Davis and his brother, Isham, left the comforts of their plantation life and bought property that later became known as Mt. Juliet. The earliest settlers in Mt. Juliet were Blake Rutland, John G. Graves, Benjamin Graves, Thomas Watson, Joseph Watson, John Wilson, John Williamson, Henry Thompson, Ezekiel Cloyd, Anderson Tate, Jacob Woodrum, Ezekiel Clampet, Andrew Wilson, and John Cawthon, among others. The original Mt. Juliet began to take shape a half-mile south of the present downtown site on the old stagecoach road, now Old Lebanon Dirt Road. When the village formed in 1835, it was a plain hole in the road, maybe a mile long. Riders on the stagecoach could stop to refresh at the Eagle Tavern, partaking of a mint julep, as Pres. Andrew Jackson of the nearby Hermitage perhaps did. On a small hill or "mount," landowner John Davis built the first residence, a cedar-log home.

When people first started settling into Mt. Juliet, the forested terrain was unsuitable for raising stock and planting crops. Determined to build a new life, though, the settlers cleared the land and cut down the trees to build cabins. Deep roots were unearthed and rocky soil tilled over to create fields for corn, cotton, and flax, among other staples. An agrarian community developed where people lived by plow and by prayers. Faithful, hard-working farmers kept a roof over their heads and food on the table by the sweat of their brow. Whistling while they toiled, a melodious symphony of nature played. Chirping crickets, croaking frogs, tweeting birds, mooing cows, bleating sheep, and ringing cowbells formed an impromptu ensemble. There was little time for play, but what social activities people enjoyed were combined with chores. For instance, strong men matched their ability to husk corn against each other in "husking bees," and women would chatter and put their fingers into overdrive for a quilting bee with their friends.

The first roads were natural paths or trails that the animals and/or Indians made as they walked to the water. Travelers who rode in wagons and carriages often found themselves in the twisting roadways, stuck in deep ruts. Extended travel by the rugged roads was impossible much of the year. So it was a major development when, in 1870, the first railroad, the Tennessee & Pacific Railroad, came into West Wilson County, not far from Mt. Juliet. The new transportation allowed farmers to send their cattle, sheep, and crops to distant cities. Eventually, the Nashville, Chattanooga & St. Louis Railway (NC&StL) took over, but in 1901, it started facing competition from the Tennessee Central Railway (TC), which offered extended services into East Tennessee.

Seizing the opportunity to capitalize on the rail's assets, young entrepreneur J.W. Grigg became the first to open up a business near the rail service. Other wise men followed suit. As people from the "mount" moved closer to the railroad station, the hub of activity transformed into the new Mt. Juliet, along what is today Division Street. Mt. Juliet began to transition from an agrarian community to a commercial village as families began earning money with jobs outside of farming. Mt. Juliet became a resort town of sorts. Outside neighbors would travel here for horse races and baseball games on the weekends, and enterprising people would rent out part of their homes to the guests.

Church was another integral part of the small community. At one point, entire families would move to campgrounds for weeks at a time to attend a revival at Stoner's Creek Presbyterian Church. People praised and prayed in small groups, forming religious bodies for the Church of Christ and Baptist, and Methodist churches. Church was more than a day of rest on Sundays. It was a way of life that dictated what people wore, what they said, and how they acted.

Transportation was a huge reason why communities set up their own one-room schoolhouses. Formal education started at the present site of Cloyd's Cumberland Presbyterian Church. In 1854, Mt. Juliet High School was established. Kids from neighboring counties would attend and be boarders in the homes of local folks. Following through on people's recommendations, William Caldwell opened a private school in 1890. Later on, James Scobey formed a private boarding school for girls named Oakland. Students walked or rode horseback to school, while some children commuted from other areas and boarded at the schools through the week. In time, a school that encompassed all grades opened, bringing students from around the area to study together. As the town blossomed in the 1950s and 1960s, children were separated into elementary, middle, and high schools.

People had to lean on their convictions during the Great Depression. No money meant walking for many of the farmers who already were financially strapped, with few markets for farm products. Families could feed themselves, but that was it. As if economic woes did not present enough problems, an arsonist wreaked havoc in the community. A nine-year-long series of devastating fires at schools and two Baptist churches ignited fear and outrage.

The origin of Mt. Juliet's name has been the subject of friendly debate over the years. During a discussion at the Mt. Juliet Men's Club in the 1940s, some suggested the name came from the libation, mint julep, which was sold at the local watering hole, Eagle Tavern. But preacher R.V. Cawthon could not bear to see his hometown named after that kind of spirit. Others believe the moniker was bestowed upon the city as an homage to Julia Jennings Baird Gleaves, a saintly woman who helped the needy during the Civil War. The community, however, had already been established before Gleaves moved to the area. Some historians have settled on the name's beginning from Mount Juliet Estate in Ireland (see page 10).

From a stagecoach stop to a thriving suburb, Mt. Juliet has undergone a dramatic transformation over the last 200-plus years. Unfortunately, for history lovers, few of the early buildings were spared the wrecking ball. Many of those treasures are gone forever except in the hearts of the descendants and in the preserved photographs in this pictorial collection.

One

THE EARLY DAYS OF
MT. JULIET

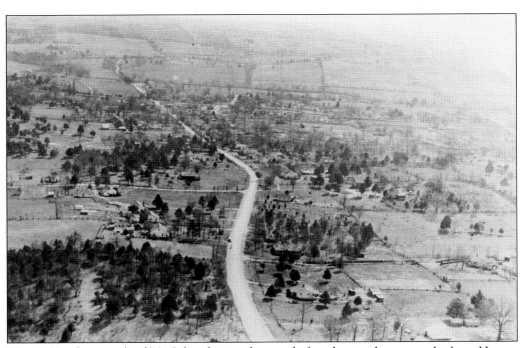

This 1940s photograph of Mt. Juliet depicts the area before drastic changes took place. Here, a few businesses and a handful of farm homes dot the countryside. This scene is the location today of the library, looking south toward the "mount" of Mt. Juliet on Old Lebanon Dirt Road.

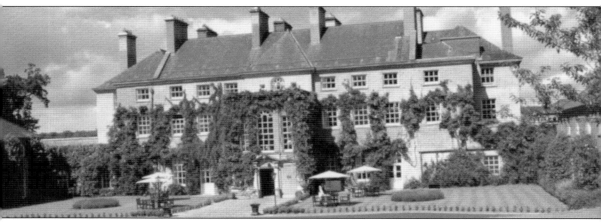

Some historians say the little village derived its sobriquet from the Mount Juliet Estate (pictured here) in Thomastown, Ireland. Now a hotel, the mansion was the seat of the earls of Carrick (surnamed Butler) for 250 years in the pastoral countryside about 85 miles from Dublin. Many members of the upper-class Butler family immigrated to America. Col. Robert Butler, who owned land in Wilson County, knew John Davis, the owner of the two-story house that was called Mount Juliet. The home was located on Old Lebanon and Nashville Roads, about one-half mile west of Eagle Tavern. Butler may have suggested the house's name to Davis.

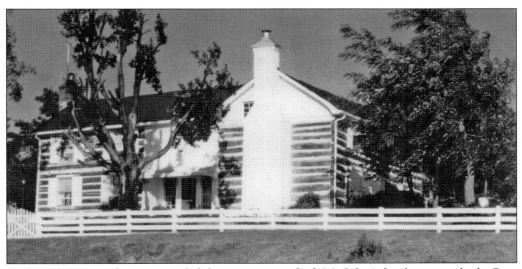

In the early 1800s, John Davis settled the property on which Mt. Juliet's first house was built. Over the years, the homestead changed hands, to John Crudup, James Harrison Osment, Omar Weston and Elaine Osment-Weston (James Harrison's daughter), Horace Osment (James Harrison's son), and then to the Stewart family. On February 7, 1958, nearly a year after Harold Stewart bought the property, fire completely consumed the house. A brick home was built on the same spot, on 4300 Old Lebanon Dirt Road, in 1959. Photographer Ernest Ingleheart, Virginia Stewart's brother, took this photograph of the log residence in the summer of 1957. The home had undergone an extensive renovation; the cedar logs were finished in a "bright cedar" appearance.

While John Davis was constructing his Mt. Juliet house/ plantation (1800–1816), his brother Isham Fielding Davis was building his home a half-mile east on the same old wagon road. Isham applied and received a license to operate an ordinary in his home. The infamous Eagle Tavern may have been a stopping place for Pres. Andrew Jackson, traveling from the nearby Hermitage. The later owner, J.P. Cawthon, turned the watering hole into a saddle shop. Following his death, James Edwards Cawthon transformed the place into a broom shop. Homemade brooms were fashioned from broom corn grown on the farm at the old Logue place at Sugg's Creek.

The Mt. Juliet Weekly News

THE TOWN WITH A FUTURE

Entered at Second-Class Mail Matter Dec. 31, 1915, at the Post Office at Mount Juliet, Tennessee, Under Act of March 3, 1879.

VOL. 2 MOUNT JULIET (Wilson Co.), TENNESSEE, FRIDAY, MAY 5, 1916. NO. 18

Box Supper.

Quite an interesting and enjoyable affair of Tuesday evening was the box supper at the school building, given by the ladies of the Mt. Juliet Methodist church.

A splendid programme, consisting of music, recitations and songs, was rendered by Misses Darleen Weaver, Elizabeth Ward, Johnnie Belle Weaver, Beulah Duke, Marie Weaver and Jessie Mai Nokes, after which the boxes were auctioned off by J. C. Carver who proved himself to be quite efficient along this line. The boxes being sold, the purchasers and the young ladies who had furnished the boxes proceeded to partake of the bountiful feasts contained in the boxes, and enjoyed the accompanying social pleasantries.

The boxes all brought a nice sum, which will be expended for the benefit of the Methodist church.

Mrs. Knox returned home Tuesday from St Thomas Hospital.

Green Hill.

Shack Lowe is on the sick list this week.

Ed Hunter has been quite sick for several days.

Mrs. Eli Smith is no better.

Mr. Ed Marlin's father has a second stroke of paralysis and is very sick.

Mrs. Henry Carter has returned from Columbia where she was called to the bedside of her mother who she reports is improving.

Edward Rice is visiting his grandparents at Green Lawn.

Mr. and Mrs. Bradford and Mrs. Lane have returned to Nashville after visiting Mrs. Hunter.

Benton and Clarence Lowe spent Sunday at Laguardo.

Mattie Hunter and Ellen Carter were in Mt. Juliet Sunday.

Mrs. P. H. Fraser visited Mrs. Kimmons Sunday.

Mrs. Hooper Rice and Mrs. Tom Rice have returned to their home on Central Pike. Ruth.

T. G. Carver is on the sick list this week.

A large crowd of young people from Mt. Juliet attended the concert at Green Hill Friday night.

Mrs. Myres of Nashville visited Mrs. E. A. Collin Thursday.

Central Pike.

Mr. and Mrs. W. B. Bryant visited Mrs. Bob Baskin Sunday.

Mrs. Lennie Brown of Henderson Cross-Roads was the weekend guest of her sister, Mrs. Lillie Williams.

Mrs. Kate Haralson spent Sunday with Mrs. Jennie Bell Baskin.

Mrs. Sallie Jones was a ——— of Mrs. Virgil Wills Saturday.

Miss Gladys Clark visited Miss Lena Williams Sunday.

Mrs. Virgil Wills and children were guests of Miss Mattie Smith Sunday afternoon.

Mr. and Mrs. Justus Williams visited Mrs. Williams' mother Saturday night and Sunday.

Miss Rina Yelton has taken Miss Grace Riggan's place as teacher at Rice's since Miss Riggan got married.

Miss Myra Hewgley visited Miss Ella May Estes Sunday night.

Little Lafton Baskin was the guest of his aunts, Misses Mary and Ann Bryant Saturday.

We are sorry to hear that Dock Haralson is confined to his bed again.

Miss Ozella Smith is reported to be no better. Red Bird.

Green Hill School Closes.

The school at Green Hill, Miss Effie Sweatt teacher, closed a very successful term last Friday. A splendid and appropriate programme was rendered Friday night by the pupils. The programme consisted of songs, music, recitations, monologues, etc., which were enjoyed by the large crowd present. Miss Sweatt is to be congratulated on her success, and the pupils deserve great credit for the manner in which they carried out their part of the exercises.

Card of Thanks.

The ladies of the Mt. Juliet Methodist Missionary Society ——— to thank the ladies of the ——— —hes for their aid in ——— the box supper Tuesday night a success, and also wish to express their appreciation of the liberal patronage and splendid behavior of all those present.

Mrs. Mollie Turner, Pres.

Read all about it! This is the front page of the *Mt. Juliet Weekly News* from May 5, 1916. The paper's apt slogan was "The Town with a Future," though few could have predicted the massive changes that lie ahead. The main headline of the day was "Box Supper."

A kid could get a haircut from barber Joe Hunt for two bits. With sheer determination to make his business work, he set up shop in his home, which is pictured here with his wife. He also practiced medicine, carrying on a tradition that dates back to medieval times, when barbers performed surgery on customers. The red-and-white pole outside Hunt's shop indicated that the stylist was open for business. The pole is associated with the service of bloodletting, and in ages past, it represented bloody bandages.

The Bank of Mt. Juliet, seen here in 1940, was the first financial institution in Wilson County. Chartered in 1908, it is the only bank in Wilson County that remained open through two major wars and a severe depression. The institution was bought out by First Southern Bank.

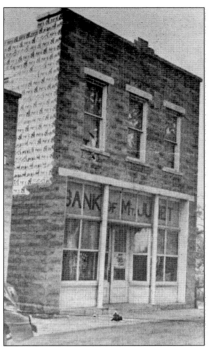

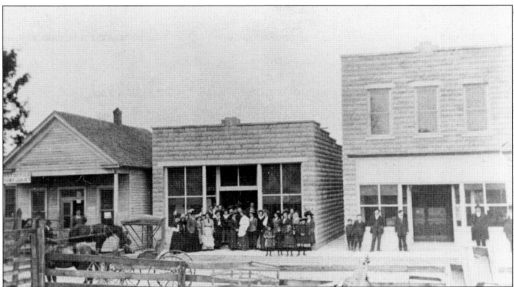

Mt. Juliet had scant few businesses in the village's horse-and-buggy days. Shown here are, from left to right, the post office, the Carver Store, and the bank. On the second floor of the bank was the telephone office. J.W. Grigg and S.M. Smith organized the Mt. Juliet Telephone Company in 1902 with only 12 telephones or stations. The telephone company began with a switchboard placed on a wooden box in the back of Grigg's store. The first operators were Elwyn Weston and Robert Fuqua. John Wood and John Carver bought the telephone company and moved it to the bank building in the World War I era. In those days, talking on the phone involved no privacy, thanks to eight-party lines. Often, there was more eavesdropping than talking.

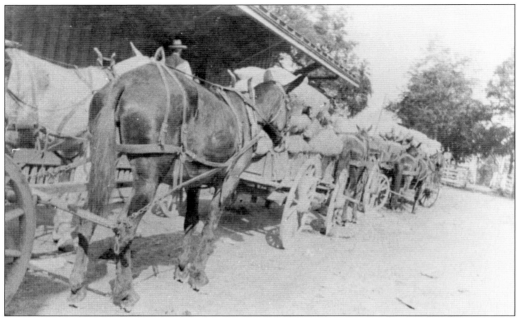

These photographs date to 1875, when the residents turned to agriculture for their bread and butter. Wool was a huge commodity. When the sheep were sheered and the harvest of wool was ready to be shipped off, the town would hold a big bash. Farmers paid the railroad to carry the wool into Nashville, and from there, it would be shipped across the country.

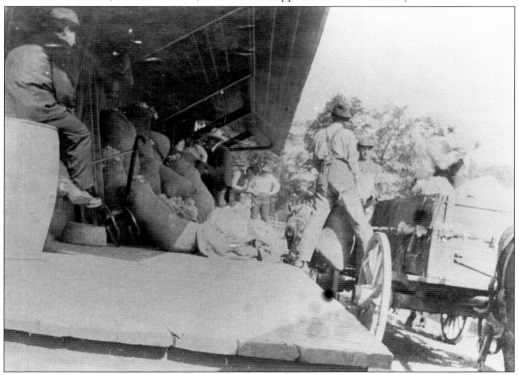

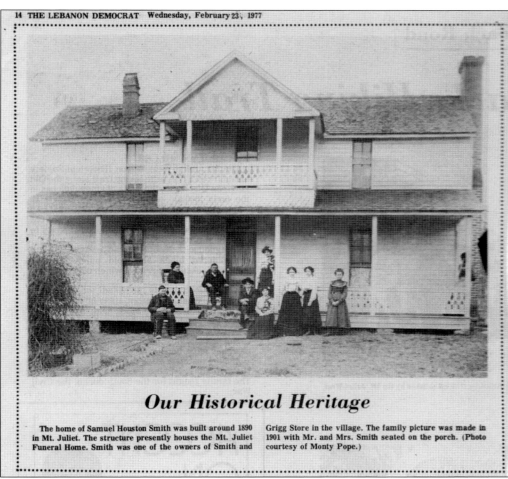

Our Historical Heritage

The home of Samuel Houston Smith was built around 1890 in Mt. Juliet. The structure presently houses the Mt. Juliet Funeral Home. Smith was one of the owners of Smith and Grigg Store in the village. The family picture was made in 1901 with Mr. and Mrs. Smith seated on the porch. (Photo courtesy of Monty Pope.)

On February 23, 1977, the *Lebanon Democrat* featured the home of Samuel Houston Smith, which was built around 1890. This family portrait, with Mr. and Mrs. Smith seated on the porch, was made in 1901. Besides being the Smith residence, the building also served as their grocery. Workers would come for a big bologna sandwich during their lunch break. The home was also a parsonage for a preacher and was Mt. Juliet Funeral Home.

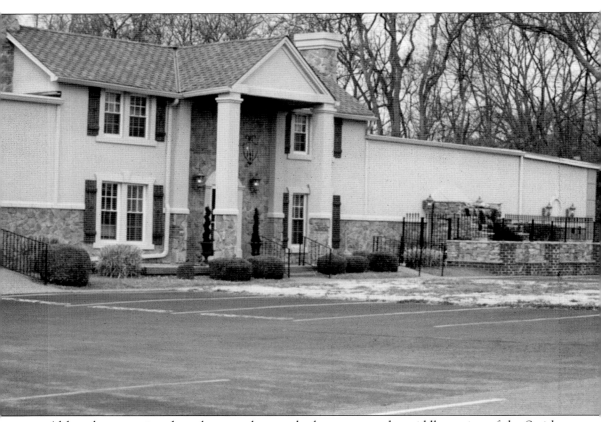

Although renovations have been made over the last century, the middle section of the Smith house has survived. Today, it's known as Sellars Funeral Home.

Taking Tea With Dolly

"Will you let another day go by without a Telephone in your home?" This page from the *Mt. Juliet Weekly News* of December 24, 1915, touts the virtues of owning a telephone. The Moore-Stratton Buggy Company of Lebanon advertised the best transportation buys on a buggy, and the train schedules were printed for the Tennessee Central Railroad and the Nashville, Chattanooga & St. Louis Railway.

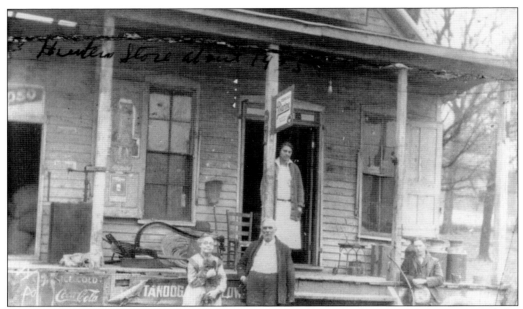

For more than 60 years, the Rice family has been curing country hams. Ed Rice Sr. started the business in his backyard smokehouse in 1950. Pictured above in the early years is the building that became Rice Country Hams. From left to right are William T. Hunter, Hattie Bradford Hunter, Edna Hunter, and Dick Mills. In the early 1980s, Ed Jr. (below) took over the business, and now his daughter and son-in-law are in charge. Rice Country Hams has earned a mantel full of trophies and ribbons from county and state fairs for four decades, and the family business has been featured nationally on *The Martha Stewart Show*. They credit "Mother Nature and Father Time" for the quality of their ham. In times past, the building, which opened in 1886, was a country store for the community. (Both, courtesy Ginny Rice Dabbs.)

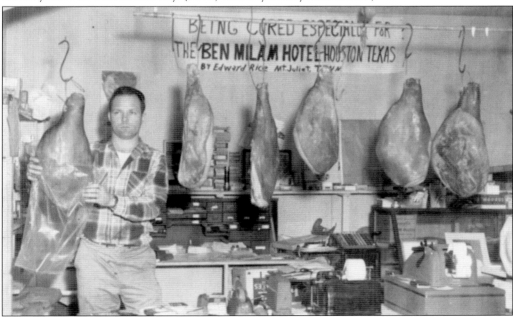

George W. Wright ran the Dodoburg's Post Office from 1884 to 1903. The store was later owned by the Jim Eakes family. The Graves family bought the store, and it remains in their hands today. The Graves family established a 100-acre farm in 1839. The land was used to raise grains, dairy cattle, swine, horses, and mules, and was also used by troops that camped there during the Civil War. Gen. George S. Patton conducted maneuvers of the 2nd Army on this land.

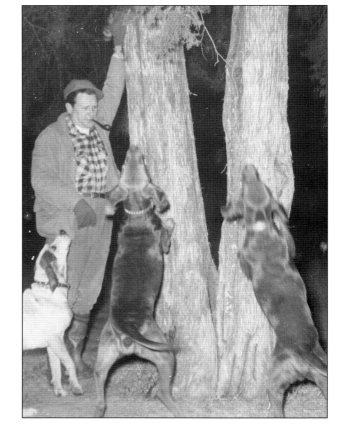

When he was not busy working, Grafton L. "Pap" Graves loved to coon hunt. He is pictured here with his coon dogs, who are apparently quite excited about something they treed.

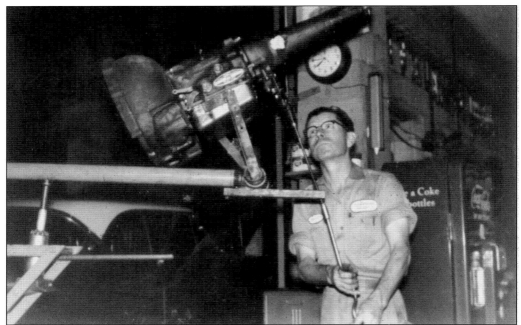

Self-taught mechanic Macon Castleman was one of the best automobile experts around. Like a skillful doctor, he could look under the hood of a car and, upon examination, diagnose the source of the mechanical or electrical problem. This photograph, the only one of Castleman at work in his garage, was taken about 1959. He is checking out a 1952 Ford automatic transmission. Not only did he teach himself the extremely complex skill of rebuilding a transmission, but he also made the transmission hoist shown here. He is shown adjusting the mechanism he designed, which enabled him to tilt the rear of the transmission at the angle needed for its tricky removal and installation. (Courtesy Castleman family archives.)

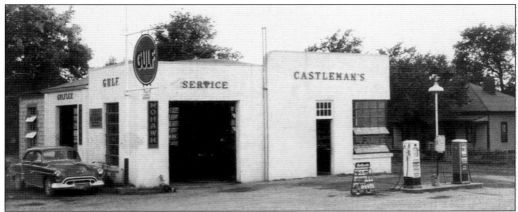

Located about 100 feet from the Tennessee Central train station, Castleman's Garage, or "The Shop," was the place where townsfolk would come when their car was thirsty for gasoline or needed maintenance. When this photograph of the old concrete-block building was taken, sometime around 1952 or 1953, Castleman had just added pumps in order to sell Gulf gasoline. People would either shout "put it on my account" as they drove away or pay the 25¢-a-gallon price in cash. An attendant pumped the gas, cleaned the windshield, and at least offered to check under the hood. (Courtesy Castleman family archives.)

N.C. "Dude" Hibbett sits in the Mt. Juliet fire engine in this 1950 photograph. It was the volunteer fire department's first motorized vehicle, which was purchased thanks to a loan from the neighboring city of Lebanon.

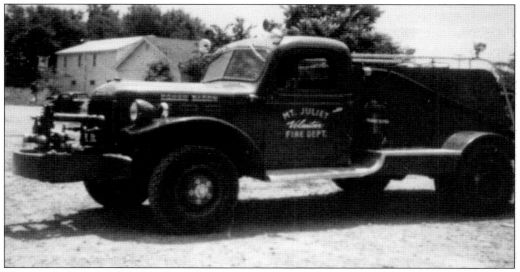

The Men's Club decided that the Lebanon loaner fire engine had seen better days, so it began to raise money for a new one. With the first few dollars, the club purchased a government-surplus Dodge Power Wagon truck chassis. Town mechanic Macon Castleman, who had been the unofficial fire chief, agreed to undertake the task to convert the vehicle into a fire engine, which included rebuilding the truck engine, installing a specially crafted water pump, painting it red, and adding other firefighting equipment. Many man-hours later, the Mt. Juliet Fire Department had its own fire truck, pictured here in the early 1950s. The vehicle's top speed was 40 miles per hour, due to the additional two tons of weight from the firefighting apparatus and 500 gallons of water. Since there was no public water supply, firemen had to fill up at Stoner Creek, just below Mt. Juliet Church of Christ. (Courtesy Castleman family archives.)

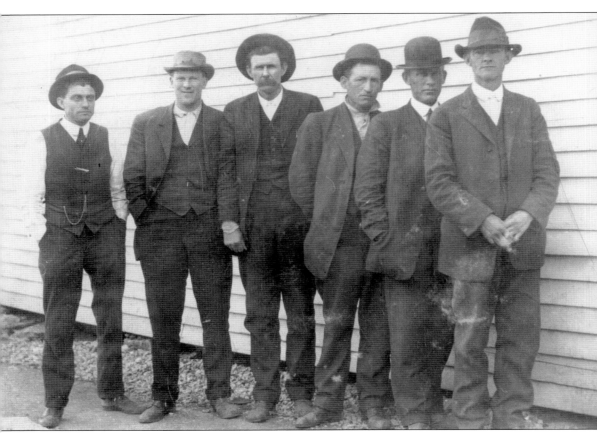

Bob Bell was a postal worker for the Central Pike area in the early 1900s. He always used a horse-drawn vehicle, even after cars were in general use. Whenever he would meet a car along his route, Bell would pull over and stop, get out, and feed his horse. On one occasion, someone stopped and asked if his horse was afraid of cars. He said, "No, but I am!" Shown here are, from left to right, the Mt. Juliet postmaster and rural route carriers: postmaster J.D. Sperry; Guy A. Murray, Route 1; Monroe Wright, Route 2; Garfield Boyd, Route 3; Bob Bell, Route 4; and Benjamin "Ben" G. Yelton, Route 5.

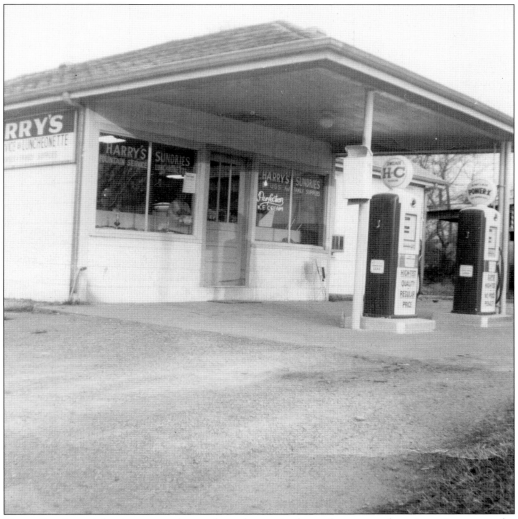

Harry Snodgrass's business was the modern-day equivalent of one-stop shopping. He operated a filling station and sold sundries. The war veteran hit the beach on D-Day as a jeep driver and was among the first to enter one of the Nazis' death camps. When he came back home, he worked at the Ford Glass Plant and opened this store, selling gasoline. In the mini-restaurant inside, customers could buy a sundae, a hamburger, or a milk shake.

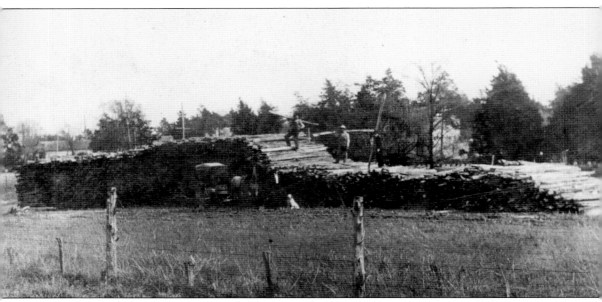

The logging industry was a huge source of revenue for Mt. Juliet in the early days. With a plentiful supply of trees in the area, F&O Cedar Company, located next to the Tennessee Central Railroad, kept its logging operation in overdrive.

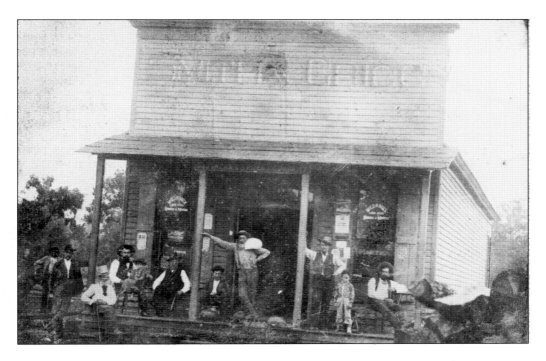

The Smith and Grigg store was the first official business in the village of Mt. Juliet. Mr. Grigg sold railroad tickets and medicine, and he accepted mail for loading on the train. The business opened in 1871, and the town's first telephone was installed here. Grigg partnered with S.H. Smith in the dry goods business.

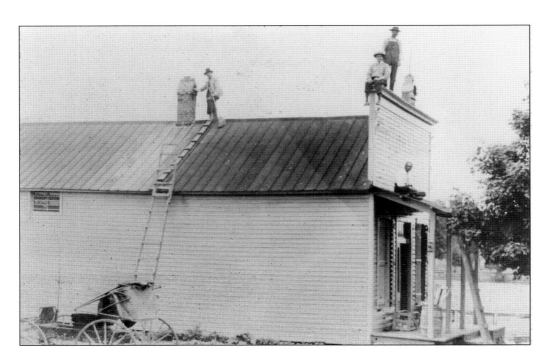

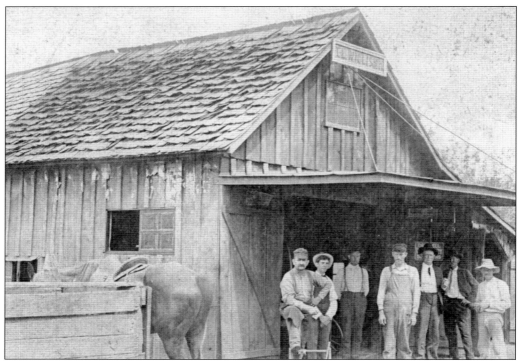

Tom Willis knew how to handle animals. Constantly twirling his handlebar mustache, the blacksmith would gently shoe horses that were brought into his shop (shown above). His business was located behind his house on Division Street, behind McFarland's gasoline station. On one occasion, the city's future first mayor, N.C. Hibbett, stopped by as a child and noticed a horseshoe nail that he admired. Thinking that he could fashion his find into a ring, Hibbett snuck away with his new possession. His dad had other plans, though, when he found out, demanding that his son promptly return the nail with a sincere apology. When Hibbett brought the nail back, Willis replied, "Thank you, son, but you didn't have to do that." The photograph below is of Willis's first blacksmith shop, which later burned down. Willis is seen above, at left with a mustache.

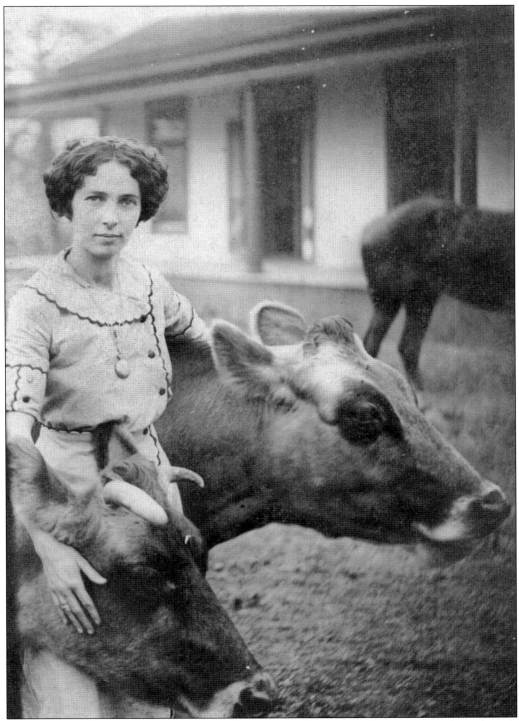

Dairy was a key industry for families in the community. Here, Ruby Wright Sperry stands with two of her cows.

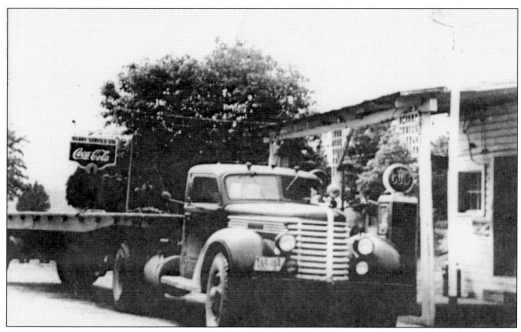

Fill 'er up! Mabry's Service Station, on Lebanon Road, pumped gas for the customers with a smile. The site is now Mike's Tires, Oil & Lube.

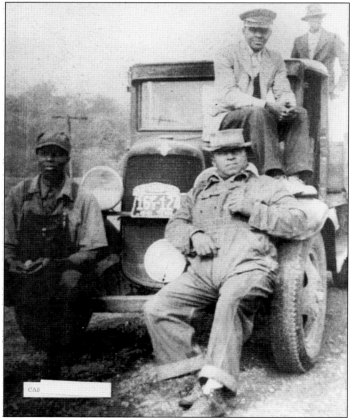

Carman Manning (pictured on the right front of the car) apparently did not sit around too much. He had the reputation of being the town's number-one stonemason.

The Mount Juliet Post Office was established on April 29, 1872, two years after the first railroad arrived. The postal service moved around a few times in the town's history. The building pictured here later became a feed store for all kinds of livestock.

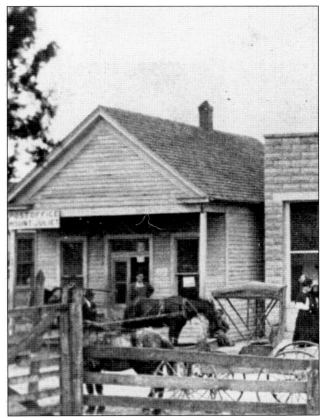

Another home of the post office was in Petty's Grocery Store. Shown here is the front of the post office, which faced north. The grocery faced south. On this snowy day in 1959 or 1960, Ron Castleman makes his way back to his garage. (Courtesy Castleman family archives.)

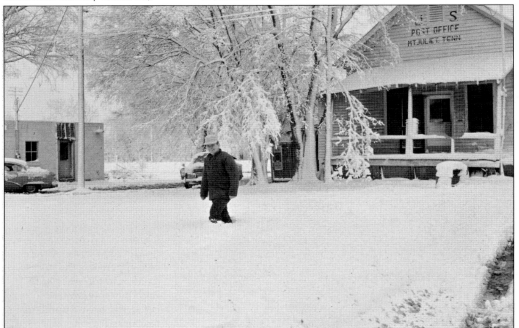

The Bank of Mt. Juliet was the first financial institution in Wilson County, and the only bank to survive the Depression. Bank board members and the bank president, Annie Lou McDaniel, who is pictured here as a child, cracked the monetary whip with great thrift and with a no-excuses attitude toward late loan payments. The bank placed high hurdles to clear to get a loan. According to N.C. Hibbett, McDaniel trained the mother of Dan Evins, who built the Cracker Barrel empire. The bank lent its upper floor to the Mt. Juliet Telephone Company at one time, and this also was a temporary meeting place for the Masonic lodge. When she was a kid, McDaniel commuted by train to school from Tuckers Crossroads. Homesick, she packed every thread of her belongings, with no plan to return. Her father had a different idea.

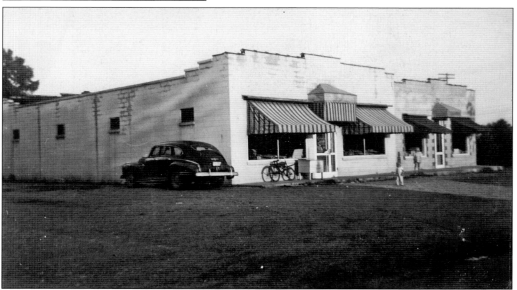

Smith's Grocery (circa 1945), built in 1941, is pictured on the left, and the Frozen Food Bank, "The Locker", added in 1945, is on the right. The Buick was Mr. Smith's. The small boy and girl standing in front of the store are Charles Lee (left) and Linda Ann McCorkle, grandchildren of C.B. Smith. Smith's Store later became known as Smith and McCorkle and finally just McCorkle's. (Courtesy McCorkle family archives.)

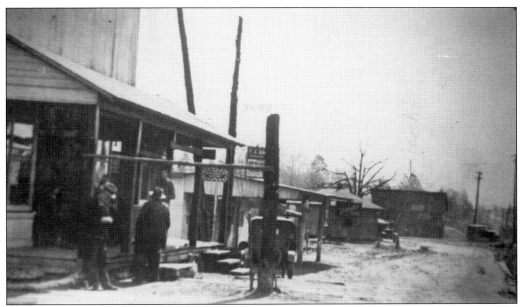

Main Street in Mt. Juliet in the early 1900s had a relaxing, Mayberry feel, with good country folks who enjoyed the simple pleasures of life. This photograph is looking east beside the railroad. The Smith and Grigg store is the first building on the left. Adjacent to it was a bowling alley that sold beer. Prohibition, however, knocked it out of business, and it later became a pool hall. The third building is Carver Caskets, which made cedar coffins.

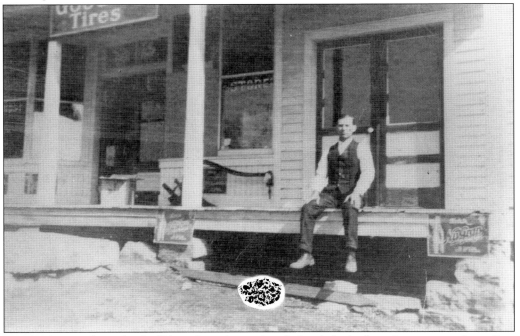

Joe Hardaway takes a load off from his job standing behind the barber chair, cutting hair. One of the main barbers in town, Hardaway added on a room to the Smith and Grigg store for his barbershop.

In the background of this photograph of four ladies is a barn where racing horses were boarded. Tighlman's Stables was the site of a racetrack that people from outside Mt. Juliet visited for Saturday races.

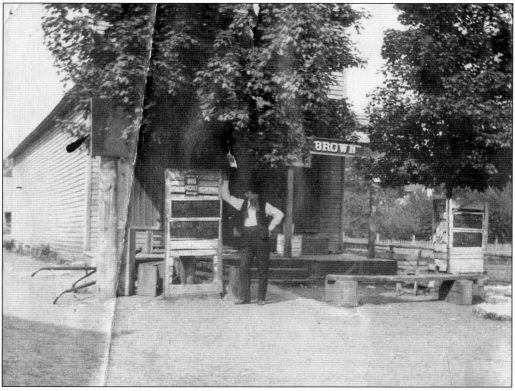

This is another photograph of the Smith and Grigg store. To the right of the business is a cornfield. Even those who ran a business or performed another job also operated a farm.

Seen here in the background is the old Rice and McWherter mule barn. Mules were shipped out of here and sent throughout the United States. For entertainment, people would watch an informal mule parade. When it was time for the trains to pull into the station, Jim McWherter would march the mules from the barn to the railroad cattle area, walking around until all the mules were present. Then, he would turn the mules around and head back home. McWherter was also a janitor at the elementary school. Many students turned to him for advice with their problems.

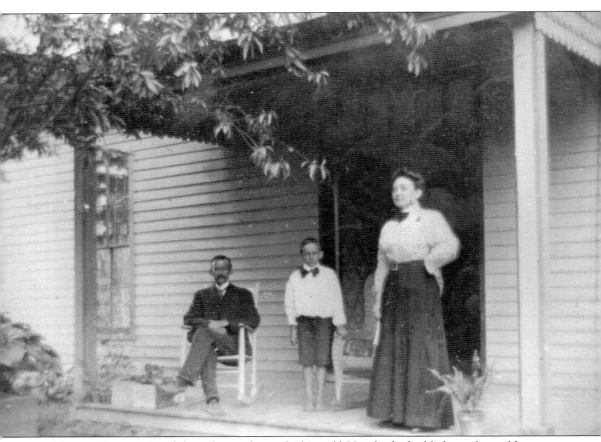

The town's mortician did not have a home for himself. His abode doubled as a funeral home, as was the case for the Hibbett family. This is the house where N.C. Hibbett was born. At the time of this photograph, J.W. Grigg's brother lived in the house.

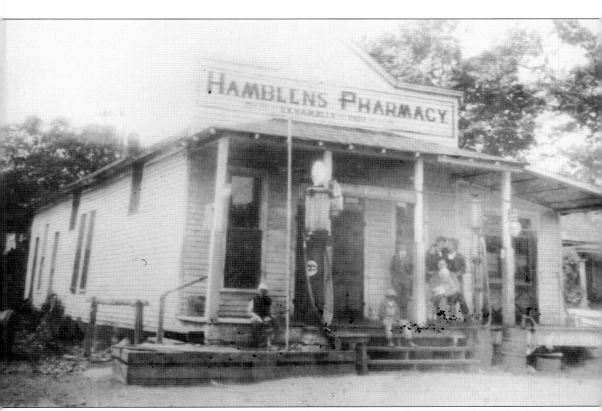

Veteran Porter Hamblen set up a soda fountain and gas pumps at his pharmacy in the early 1900s. He had gone to school to be a pharmacist in the days when that profession involved making prescriptions at the apothecary. He had a withered arm, but it did not keep him from pumping gas with his other hand.

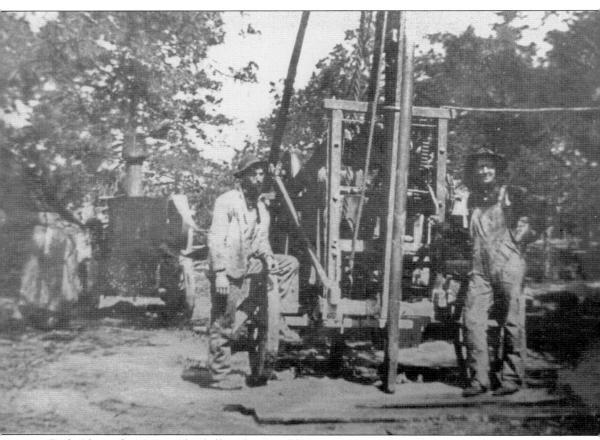

Dick Alexander was a jack-of-all-trades. In addition to serving as a magistrate and justice of the peace, he worked in the more menial occupation of well digger. All city residents had to have a well dug for water.

Two

HITTING THE BOOKS AND BALLS

In the town's early days, children attended smaller community schools. Eventually, all grades were combined into one central location. This photograph of the Mt. Juliet School, which served first through 12th grades, was taken in the early 1960s.

A McDonald's restaurant and a Publix grocery store stand at the intersection of Mt. Juliet and Lebanon Roads, where Oakland School was originally built. The finishing school for girls moved out to Highway 109. The above photograph was taken in 1976. Headmaster James Scobey established the educational institution. Two buildings for housing girls and boys were set up behind the school, which eventually became the Goodall Place. The cemetery for the Scobey and Goodall families is behind Publix.

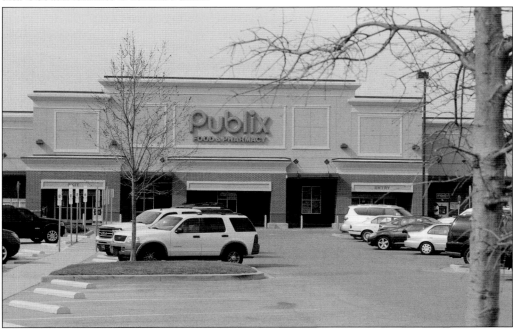

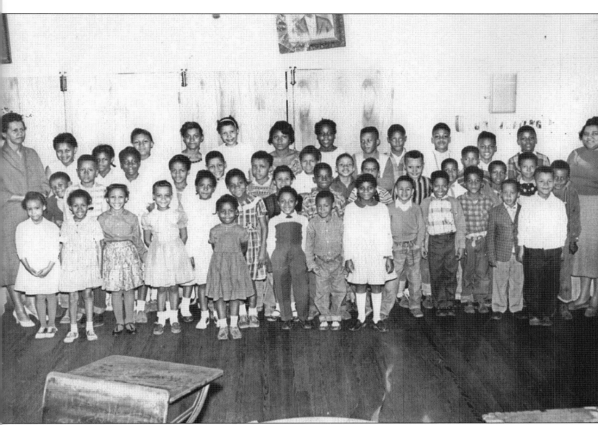

A one-room structure housed the Corona Elementary School, an African American school located next to the Corona Baptist Church. This photograph of Corona students was taken in 1959. (Courtesy Murita Hayes.)

These boys and girls prepare to take part in exercises during a physical education class. Note the modest dress for gym class—no shorts for these high school students. Basketball teams first played on the dirt court in the background.

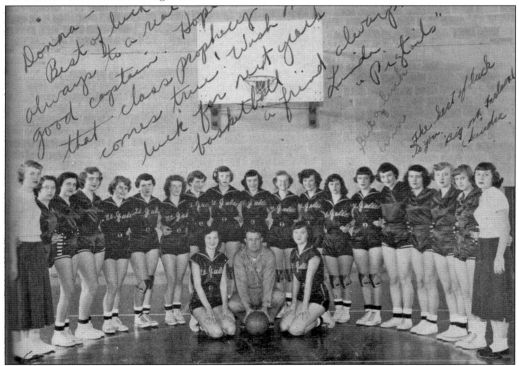

This is the 1953 Mt. Juliet High School girls' basketball team from the *Golden Leaf* annual. Charles Kosser coached the squad. The 12 girls with Mt. Juliet on their uniform are varsity. The other girls with the red DuPont hand-me-down uniforms were the freshman team. They did not dress out for games. Pictured from left to right are (first row) Donna Graves, cocaptain; Coach Kosser; and Barbara Walker, cocaptain; (second row) manager Frances George, Charlotte Page, Betty Lane, Delores Gilliam, Sandra Potter, Shirley Petty, Onita Jackson, Marie Bright, Ruth Hammers, Betty Jo Bryan, Lovelle Jackson, Sylvia McFarland, Bobby Jean Moore, Ann Burton, Sue Bell, Sandra McFarland, Linda McCorkle, Peggy Finchum, and manager Virginia Jones.

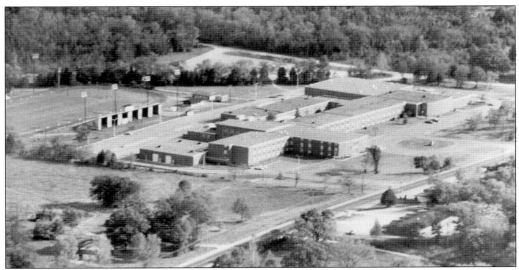

Pictured here on the left is the old Mt. Juliet High School and football stadium. To the right in the snapshot is Mt. Juliet Middle School.

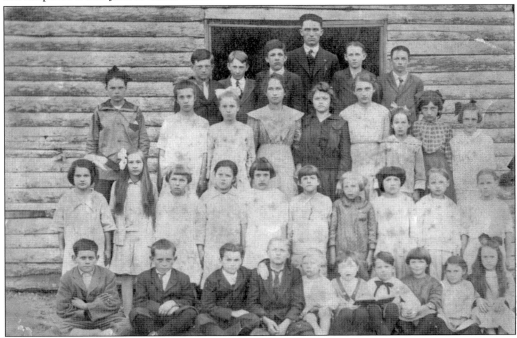

Surrounded by fertile farms, a two-room schoolhouse began operation on Central Pike (District 25) in 1879 on land donated by Sam Hamilton. The school, Hamilton Hill School, needed only one teacher. When the student body grew to between 75 and 100 scholars, a second teacher was necessary. Apparently, during one school day, Jess Oliphant had his mind on fishing more than the three Rs. He put a grain of corn on a string and stuck it through a big hole in the classroom. He certainly did not expect to catch a bluegill or crappie, but he had hoped to coax one of Mrs. Joe Jones's chickens to take the bait. It did, and Jess reeled in the frightened hen, to the kids' uproarious laughter. Shown here is the student body in 1915.

Rice's School House is another of the one-room, single-teacher community schools that served local children. It was located on Central Pike and Posey Hill Road.

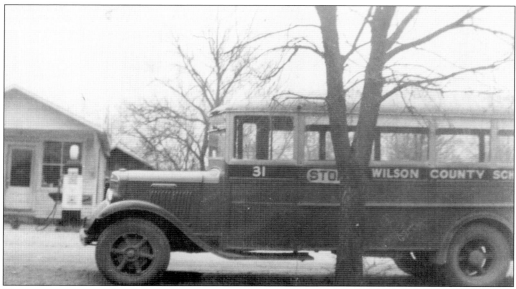

Transportation to school, now free, was paid for by parents in the early days. In the days before the now-familiar big yellow bus, the vehicle involved a truck frame with a wooden body converted into transportation for children. A bit later, buses resembled this truck (No. 31), which was used in Wilson County.

"Rusty" Ferrell (No. 13) was a tailback in the early 1950s for Mt. Juliet High School. Note the lack of protective gear and the old-fashioned leather helmet.

Something is different about this Mt. Juliet High School football team. Where are the Golden Bears' black-and-gold team colors? DuPont High School graciously donated the red-and-white outfits, because the Bears' uniforms had been destroyed in a fire.

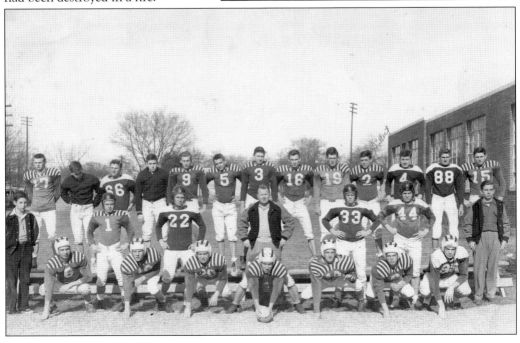

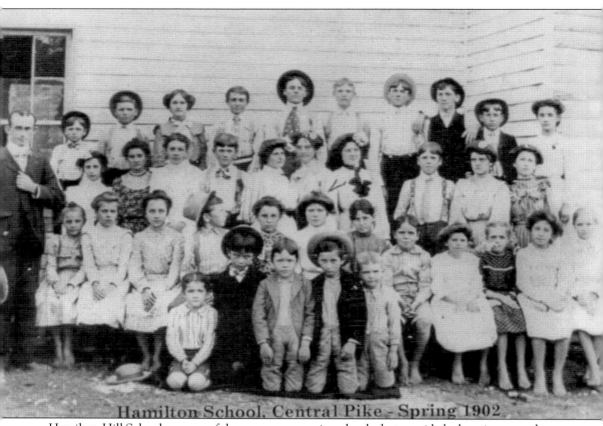

Hamilton School, Central Pike - Spring 1902

Hamilton Hill School was one of the many community schools that provided education to students in grades one through eight. Walter Rose (far left) taught this student body in the Central Pike area. Pictured here in the spring of 1902 are, from left to right, the following: (first row) Floyd Smartt, Virgil Philpot, Philip Carver, Meacham Cawthon, and unidentified; (second row) Marie Graves, Isla Graves, Wavie Wills, Herschel Carver, Rosa Bay (?), Essie Philpot, Nelle Hamilton, Orris Philpot, Sudie Shreeve, Uncie Willis, Lila Shreeve, and unidentified; (third row) Rubie Wright, Mattie Peach, Fally Jenkins, Dezzie Cawthon, Hoyte Hamilton, Nina Smartt, Mabel Carver, Ezra Philpot, Inez Cook, and Susie Brent; (fourth row) Jimmy Smartt, Gilliam Carver, Iris Carver, Clarence Sperry, Willie Cook, Claud Shreeves, Edgar Graves, Seward Jenkins, Roscoe Graves, and Bennie Bell Carver.

Elzie Patton was the longtime respected principal of Mt. Juliet High School. He moved to town from Watertown and served as a coach and typing teacher. Patton worked in the schools for over 30 years. The present Elzie D. Patton Elementary School (below) was named in his honor.

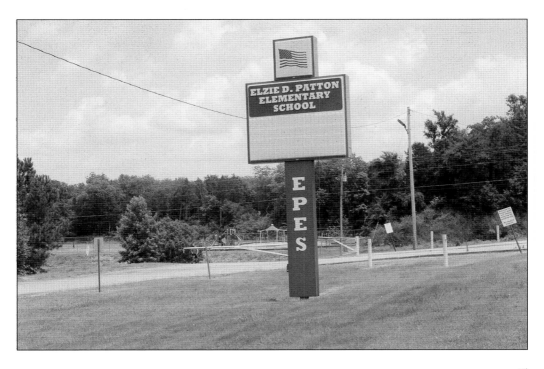

Mt. Juliet native Esther Hockett has worked in the Mt. Juliet schools for half a century. The Wilson County Board of Education recognized the Mt. Juliet High School media specialist for her 50 years of service at a February 2013 board meeting. (Courtesy Esther Hockett.)

Cedar Hill School was one of the earlier community schoolhouses. The teacher is Sarah Burton. (Courtesy Gena Sloan.)

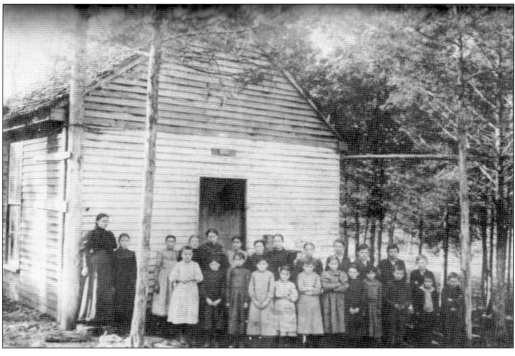

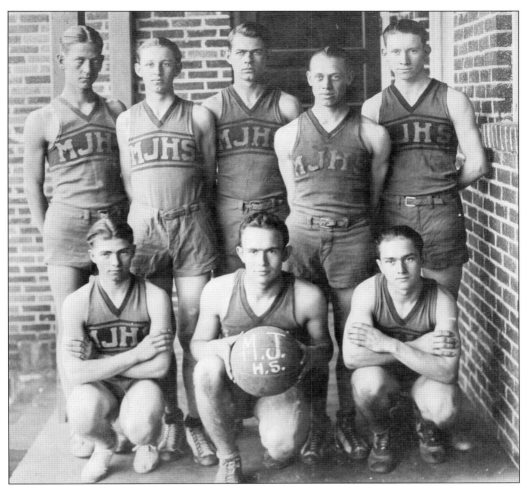

There was little room for injury on a basketball team with only a few members, but these eight boys were up to the task. Shown here are, from left to right, (first row) Buell Hardaway, James Ward, and Richard Suthman; (second row) Walter Howell, James Smith, Courtney Eskew Johnson, L.P. Major, and Ellis Crittenden (?).

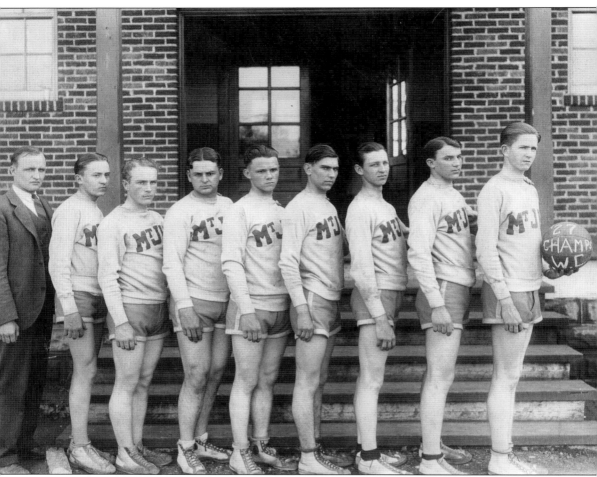

The Mt. Juliet High School boys' basketball team earned the top trophy as Wilson County champions in 1927. During this era in high school sports history, the county championship was as far as a team could advance. Shown here are, from left to right, Julius J. "Dude" Wesson, Sam Jennings, Ed Apple, Lee Jenkins, Nolen Williams, Edward Kirkpatrick, James Thayer Smith, Oscar Purnell, and Lilbrun Tinsley.

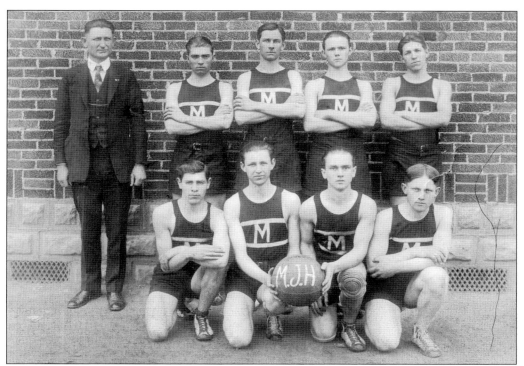

Shown here are Mt. Juliet High School basketball players around 1925. From left to right are (first row) Melvin Everett, James Thayer Smith, Richard Sullivan, and Drake Macon; (second row) John E. Moore, Buell Hardaway, Bob Tate, Nolan Williams, and Marvin Everett.

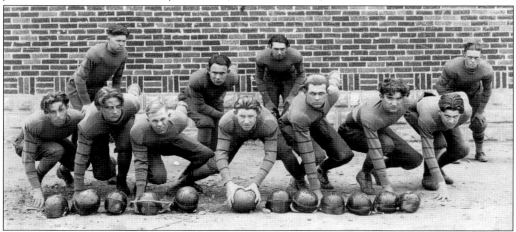

Coach Jack Gifford took this squad of players in 1923 and made them into county champs. Gifford is credited with bringing football to Mt. Juliet. A huge University of Tennessee football fan, Gifford moved to town as the first certified agriculture teacher. Although he was an aficionado of pigskin play, he did not think he knew much about the sport. But he was persuaded to coach the first high school football team. Lining up for the gridiron action in this photograph are, from left to right in the first row, Robert Lee Howell, Walter D. Howell, Grafton Major, Ellis Crittenden, Courtney Johnson, "Hap" Dodson Young, and Urban Jennings. In the backfield from left to right are James Jennings, James Ward, Earl Lehman, and Kenneth Smith.

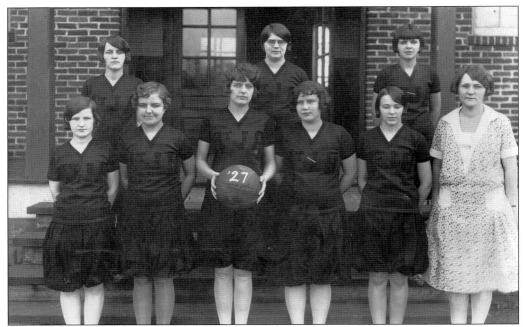

Ruby Hendrickson Major was the first girls' basketball coach at Mt. Juliet High School to use the new gym. Prior to that time, high school basketball teams played on a dirt court. Citizens moved an old wood-frame and tin-covered building from a nearby town piece by piece to Mt. Juliet for a gymnasium. Score was kept on a chalkboard above the north goal, and two coal stoves allowed players to warm their hands. The 1927 girls' basketball team is shown here.

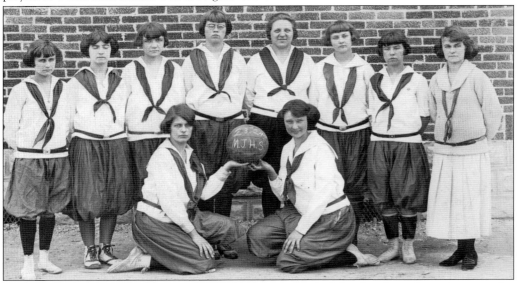

During the 1923–1924 school year, these Mt. Juliet High School girls took to the court for the Lady Bears. Shown here are, from left to right, (first row) Cliffodene Hibbett Johnson and Elizabeth Grizzard Jennings; (second row) Lucia Willow Weaver, Kathleen Sullivan, Bennie Lee Sperry, ? Lehman, Decla Horton, Christine Wright Jacobs, Tiny Sullivan, and coach Johnnie Belle Weaver.

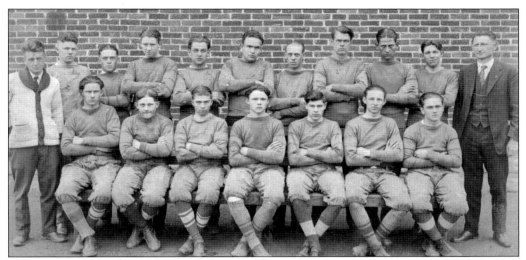

Shown here are, from left to right, (first row) Robert Tate, Drake Macon, Buell Hardaway, Nolen Williams, Melvin Everette, James T. Smith, and Richard Sullivan; (second row) Coach Gifford, James Jennings, Kenneth Smith, Ellis Crittenden, Hilton Tubb, James Ward, Pitzer Major, Courtney Johnson, Walter D. Howell, Marvin Everette, and John E. Moore.

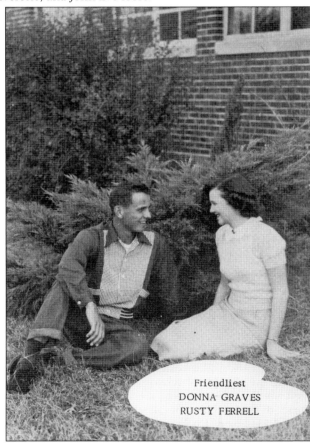

Friendliest
DONNA GRAVES
RUSTY FERRELL

High school sweethearts Rusty Ferrell and Donna Graves are pictured here from the high school annual. In 1953, classmates chose this future married couple as the "Friendliest."

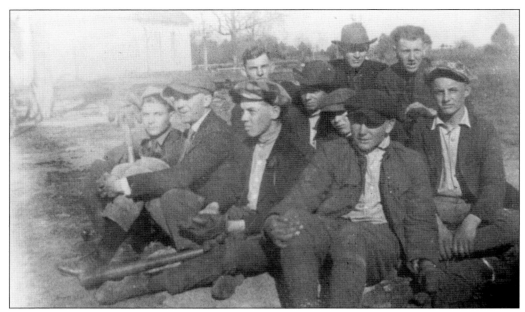

Cumberland and Wilson County leagues recruited young talent for semi-pro baseball. Among the players pictured here are Sam Everette, Horton Jennings, Pitzer Major, Grafton Major, John D. Nokes, Elde Wright, Charles Yelton, N.C. Hibbett, and Guy Wright. These men rounded the bases in one of America's favorite pastimes.

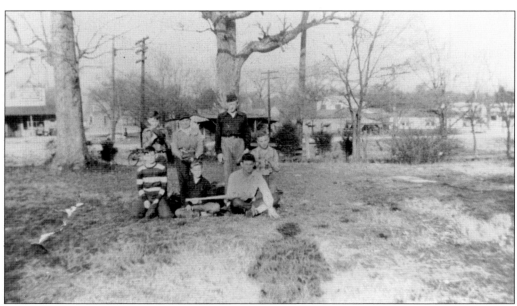

Batter up! From left to right (first row) Truman Hibbett, Bobby "Corn" Butler, and N.C. Hibbett Jr.; (second row) Kenneth Donnell, Richard Castleman, Jerry Hackney, and Jimmy Butler converted Annie Grigg's lot into a makeshift baseball field.

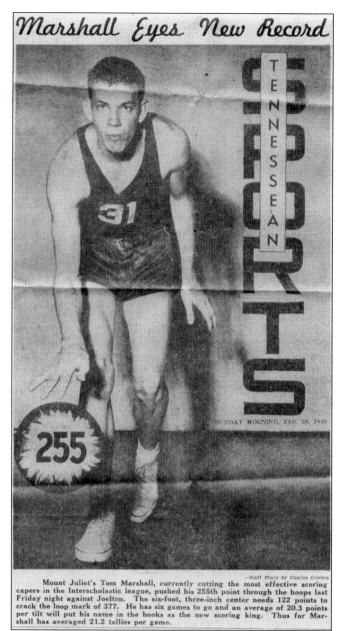

Marshall Eyes New Record

SPORTS

TENNESSEAN

SUNDAY MORNING, JAN. 30, 1949

255

—Staff Photo by Charles Cowden

Mount Juliet's Tom Marshall, currently cutting the most effective scoring capers in the Interscholastic league, pushed his 255th point through the hoops last Friday night against Joelton. The six-foot, three-inch center needs 122 points to crack the loop mark of 377. He has six games to go and an average of 20.3 points per tilt will put his name in the books as the new scoring king. Thus far Marshall has averaged 21.2 tallies per game.

Tom Marshall became the first player in Mt. Juliet to make it to the professional level. Picked seventh overall in the NBA draft, Marshall made his debut with the Rochester Royals on October 30, 1954. The six-foot, four-inch forward/guard was named to the Ohio Valley Conference Half-Century Team and the OVC 40th anniversary team. Playing for Western Kentucky University, he was the school's all-time leading scorer, with 1,909 points. His number 41 is one of only six that WKU has retired. The college once ran a promotion that would let anyone in a game for free who had a hand larger than Tom's, but Tom won, hands down. Marshall played hoops for only two years at MJHS and managed to score 1,236 points. Averaging 18.4 points per game, Marshall scored 603 points in his senior year. (Courtesy *Nashville Tennessean*.)

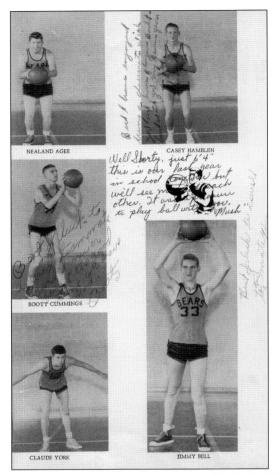

NEALAND AGEE

CASEY HAMBLEN

Well Shorty, just 6'4" this is our last year in school but we'll see each other. It was to play ball with you. Mush

BOOTY CUMMINGS

CLAUDE YORK

JIMMY BELL

This is a signed page from the 1953 Gold Bears annual. Pictured are some of the members of the MJHS basketball squad, including Booty Cummings, Nealon Agee, Claude York, Casey Hamblen, and the six-foot, four-inch Jimmy "Short" Bell, whose son Tim Bell is principal of Mt. Juliet Middle School.

At the urging of fellow members at First Baptist Church, William Caldwell began the Caldwell Training Academy in 1890 on what is now Fourth Avenue. Students walked or rode horseback to the private school, which had boys' and girls' stables. Those who lived further away commuted into the town and could board with Caldwell for a fee. Included in this vintage photograph are Professor Caldwell and his wife, Minerva Bryan, at far left on the second row.

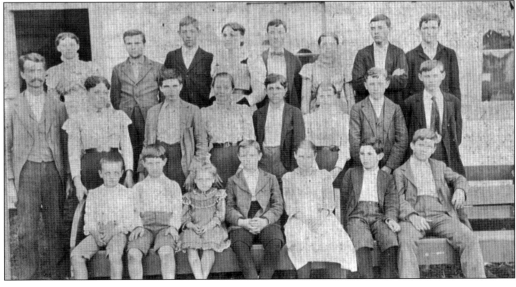

The senior class of 1924 at Mt. Juliet High School had 11 students. Rouchen Horton was the principal. J.A. Gifford taught agriculture, Lillian Barry educated students on home economics, and Jonnie Weaver taught languages. Attending that year were Sarah Elizabeth Jennings, Robert Lee Howell, Grafton Fain Major, Decla Leon Horton, Gladys Wright, Urban Jennings, Julia Mae Taylor, Mary Kathleen Sullivan, Thomas Dodson Young, Earl C. Lehman, and Ersie York.

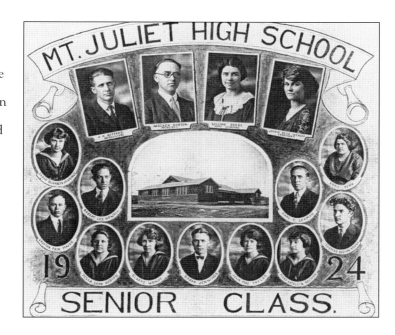

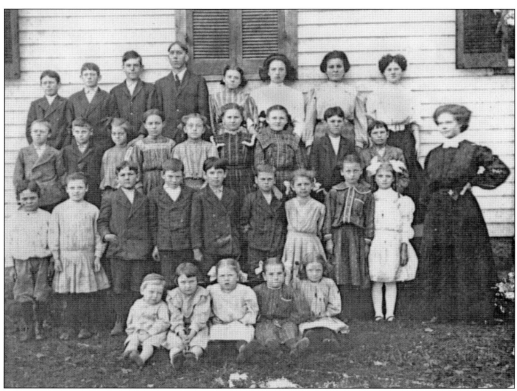

Here is another student body from one of the many community schools. These children attended the school in Nonaville, where this photograph was taken in 1909.

Bachelor of Ugliness
RONALD WRIGHT

Ronald Wright was named the "Bachelor of Ugliness" at Mt. Juliet High School in 1953. The creative antonym is an unusual title for the handsome young man, who was also named "Best Looking" along with Joan Hamblen the same year.

John Curd was president of the class of 1927 at MJHS. Robert Wilkerson was the vice president, Leah Young the secretary, and Cliffodene Johnson the treasurer. Valedictorian Fannie Mae Sherrill had the best grades.

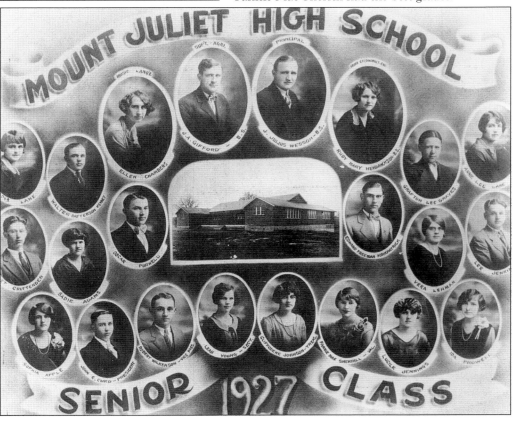

Three

ALL ABOARD!

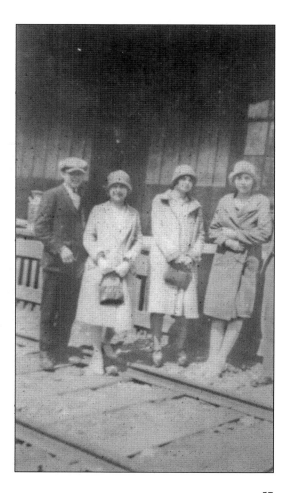

There is nothing quite like the allure of that long train whistle. For most residents of Mt. Juliet, it was the call into the wild, beyond the boundaries of Wilson County. This well-dressed group of ladies and a gentleman are at the former train depot, where they are either waiting to travel into town or have arrived from another destination. Located on what is now Division Street, the Nashville, Chattanooga & St. Louis Railway depot was the gateway for people and agriculture products to the outside world.

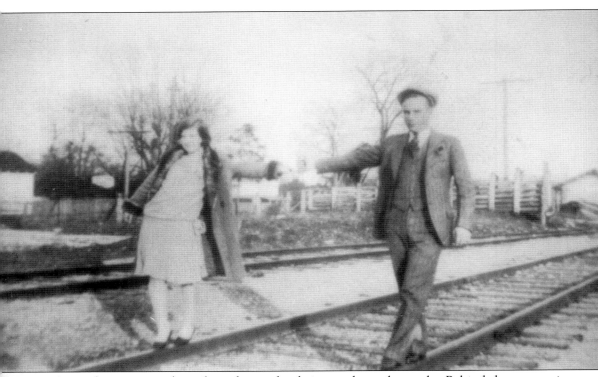

A couple teeters on the rails as they make their way down the tracks. Behind the woman is another set of tracks at Green Hill. Trains would start racing each other in a mighty dash to the finish line in Mt. Juliet.

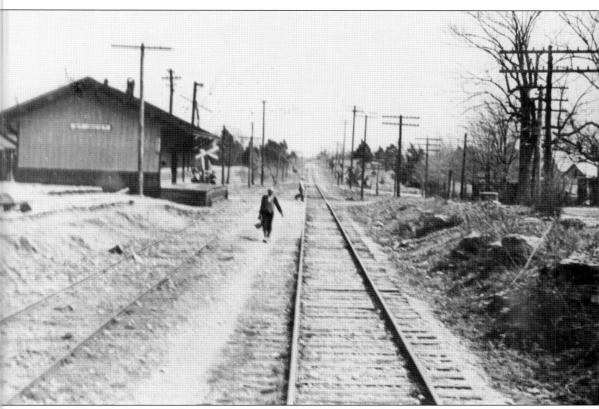

Among the jobs the railroad provided were conductors, engineers, brakemen, signalmen, yardmen, and train dispatchers. These employees kept the operation running smooth and safely. The railroaders were a special breed of workers who were true to their company. The employees of the Nashville, Central & St. Louis Railway were put out of work when the Tennessee Central Railroad essentially shut it down. The TC carried freight all the way to Knoxville. Workers could have landed a new position with their former competitors, but their diehard loyalty for the NC&StL meant more to them than a paycheck. They chose other jobs instead. Pictured here is the long stretch of railroad track and the depot that developed into East Division Street.

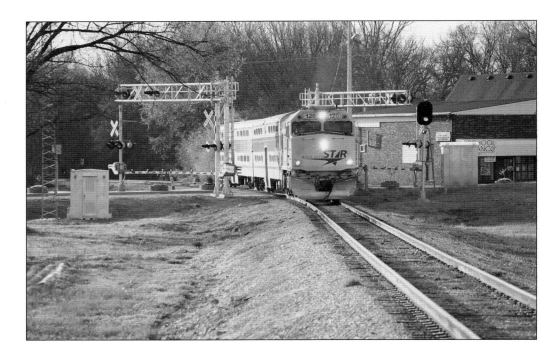

The *Music City Star* now makes stops at East Division Street and Mt. Juliet Road. In 2002, the depot was officially named after train lover N.C. Hibbett, who has a replica of old Mt. Juliet for his train model in the basement of his home.

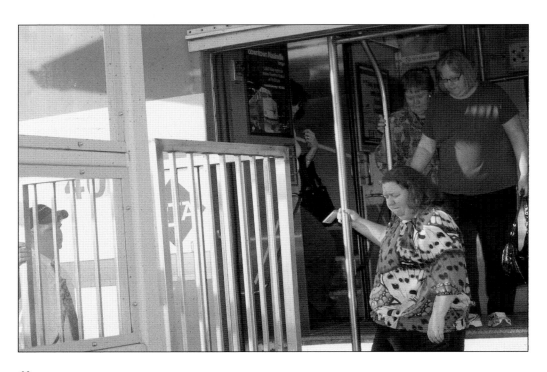

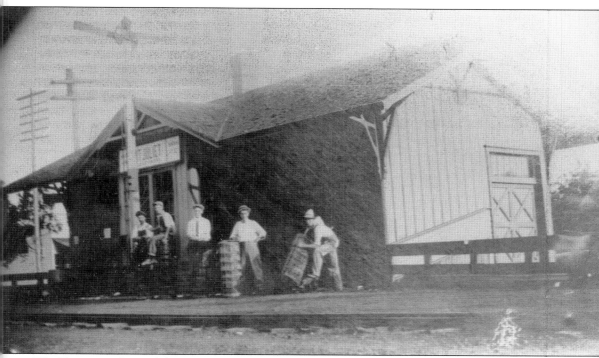

The Tennessee Central depot was razed, but before it was torn down, the shelter provided a brief respite for train travelers who waited to board or disembark. Interestingly, one end of the building spelled the city's name as "Mount" Juliet, while the other end was labeled "Mt." When the city was incorporated, the original city fathers voted to officially call the town Mt. Juliet.

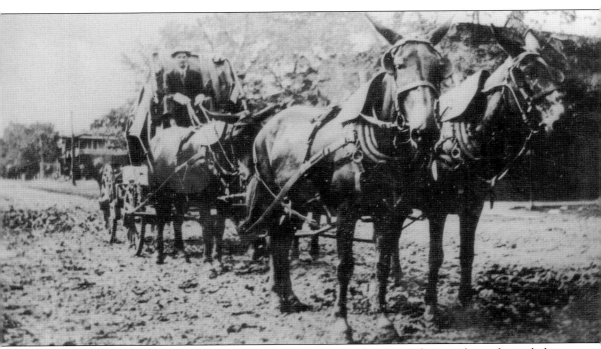

This exalted form of transportation was revered in its day. Mt. Juliet residents depended on this horse-based mainstay to haul logs, sheep, sheep's wool, and other commodities, along with passengers.

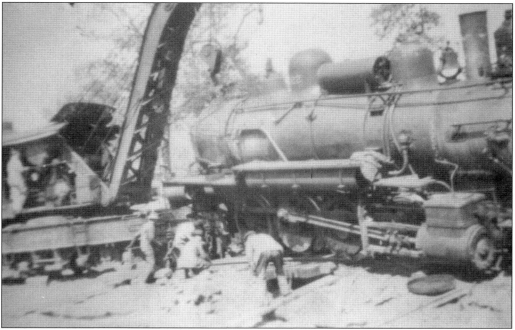

Full steam ahead! Excited locomotive engineers cranked up the speed of their trains as they raced to beat each other coming into Mt. Juliet from around Green Hill. An engineer lost control, and this train ran off the tracks and crashed. An old-fashioned crane that could ride on the tracks is pictured here as it prepares to place the engine back on the track.

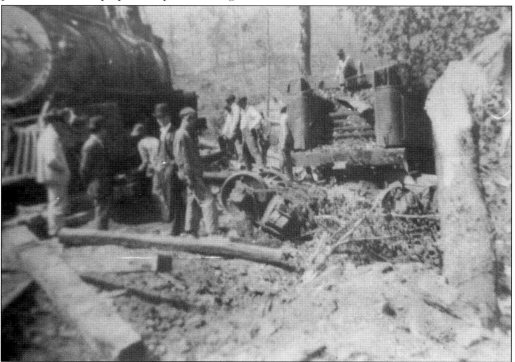

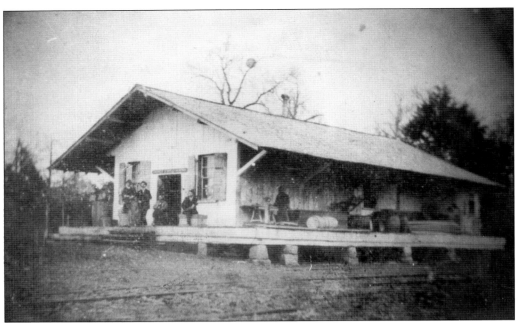

Tennessee and Pacific Railroad, PASSENGER TARIFF.

STATIONS	No. of Stations	NASHVILLE	MT. OLIVET	MUD TAVERN	DONELSON	HERMITAGE	GREEN HILL	MT. JULIET	SILVER SPRINGS	STRINGTOWN	TUCKER'S GAP	LEBANON
No. of Stations,		1	2	3	4	5	6	7	8	9	10	11
No. of Miles,		0	2	6½	8	11½	15½	17½	21½	23½	25½	30½
NASHVILLE,	1	1	10	35	40	60	80	90	1.10	1.20	1.30	1.50
MT. OLIVET.	2	10	2	25	30	50	70	80	1.00	1.10	1.20	1.45
MUD TAVERN.	3	35	25	3	10	25	45	55	75	85	95	1.20
DONELSON.	4	40	30	10	4	20	40	50	70	80	90	1.15
HERMITAGE.	5	60	50	25	20	5	20	30	50	60	70	95
GREEN HILL,	6	80	70	45	40	20	6	10	30	40	50	75
MT. JULIET.	7	90	80	55	50	30	10	7	20	30	40	65
SILVER SPRINGS.	8	1.10	1.00	75	70	50	30	20	8	10	20	45
STRINGTOWN,	9	1.20	1.10	85	80	60	40	30	10	9	10	35
TUCKER'S GAP.	10	1.30	1.20	95	90	70	50	40	20	10	10	25
LEBANON,	11	1.50	1.45	1.20	1.15	95	75	65	45	35	25	11

This is one of the stops along the way in Wilson County. The train made stops at the depot in Leeville. This building is still standing on the "Old Railroad Bed." It used to be Hargis's store but is now empty.

Here's a copy of the Tennessee & Pacific Railroad passenger tariff. Taxes were based on the number of miles traveled between stops from Nashville to Lebanon. Between those two destinations were train stops at Mt. Olivet, Mud Tavern, Donelson, Hermitage, Green Hill, Mt. Juliet, Silver Springs, Springtown, and Tucker's Gap.

Four

FAITH AND FARMING

Popular gospel minister Rufus Vester Cawthon preached for a long stint with the Mt. Juliet Church of Christ. The evangelist held over 400 meetings within a 30-mile radius of Mt. Juliet and established over 20 congregations. A man of conviction, Cawthon stood firm in the face of danger. On one occasion, an angry father threatened to gun down Cawthon if he baptized his daughter, but the minister waded out into the water and immersed the girl anyway. Later, he baptized the father.

The survival of First Baptist Church Mt. Juliet is a solid testament of the people persevering in the face of adversity. Fire destroyed two old church buildings in the church's history, but the congregants' spirit remained undeterred. In the beginning, a few folks worshipped at Caldwell Training School. Church members dedicated the first frame church on June 24, 1906. Tragedy struck the small congregation on Sunday morning, March 6, 1938, when the church building went up in flames. Many shocked members remember the sound the church bell made as it fell. It survived the heat and is installed at today's church location.

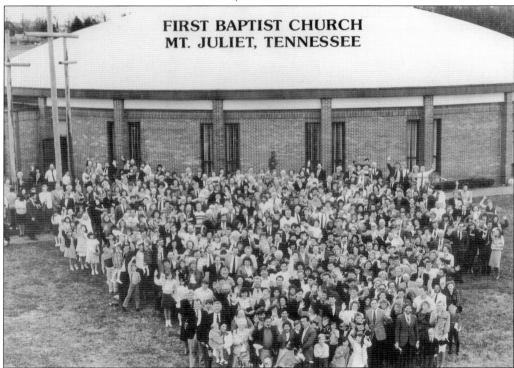

The Baptist congregation dedicated a brick building on Sunday, December 17, 1944, at the current Juliet's Wedding Chapel location (below). Flames brought down the new worship building on November 14, 1945, leaving church members homeless again. In the above photograph, Christians are lifting up praises for the first time in the future worship center. At this point, there was no roof, only a concrete slab on which the chairs sat and a steel beam skeleton infrastructure. The new building was dedicated on December 7, 1951, on 41 acres at 735 North Mt. Juliet Road. Today, the church is known as First Baptist Church of Mt. Juliet. It has an average worship attendance on Sunday mornings of close to 1,000. A new children's wing was opened on September 2, 2012, increasing Bible study capacity by close to 50 percent. Through the week, the church morphs into Mt. Juliet Christian Academy, which opened its doors in 1979.

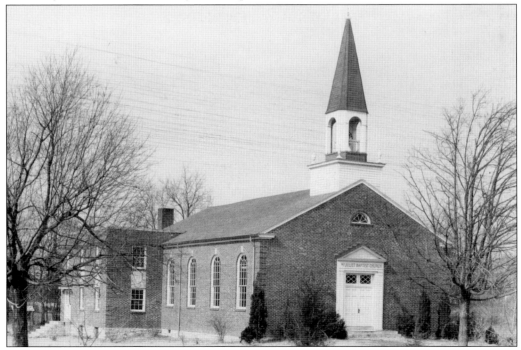

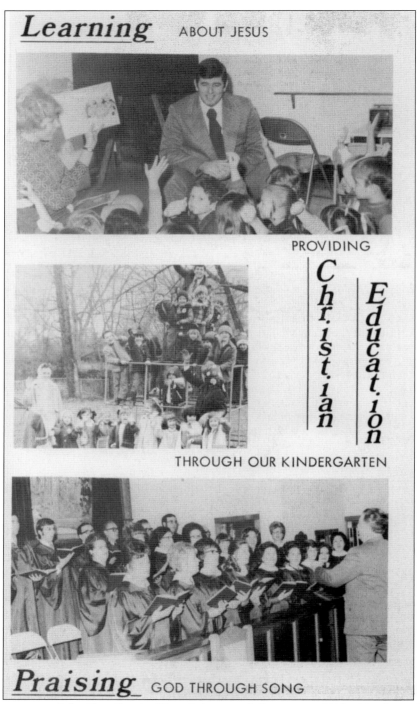

Learning ABOUT JESUS

PROVIDING

Christian *Education*

THROUGH OUR KINDERGARTEN

Praising GOD THROUGH SONG

This is a page out of the First Baptist Church inaugural directory, published in the early 1970s. Brother Billie Friel was called as the pastor in December 1972, a position he held for 34 years. Past ministers at the church included B.B. Powers, Kenneth Startup, A.A. McClanahan, William Stockton, and Charles Treadway. In 2009, Andy Hale took on the role of senior pastor.

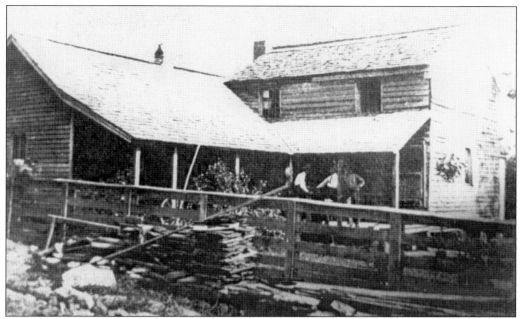

Reportedly the oldest church in Mt. Juliet, Cloyd's Cumberland Presbyterian Church started more than 200 years ago on the north side of the former NC&StL railroad. Scotch-Irish Presbyterians Ezekiel Cloyd and his brother-in-law John Williamson organized the religious body about 1799 after they emigrated from North Carolina. Services were held in a schoolhouse (above), but Cloyd donated seven acres of land for a camp meeting ground and house of worship. Named Stoner's Creek Presbyterian Church, it belonged to the revival party during the religious struggles connected with the great revival of 1800. Later, the name was changed to Cloyd's in honor of the cofounder. The first building erected was made of hewed cedar logs, but congregational growth prompted the construction of a brick house of worship in the 1820s. The bottom picture is from the ground-breaking (below) for the third church, which was built in 1968. Pictured from left to right are Reverend Markum, Charles (Jerry) Freeman, William Coley, Louis Jackson, Mark Howell, Paul Haney, Joe Petty and a glimpse of the right hand of Noel Yelton.

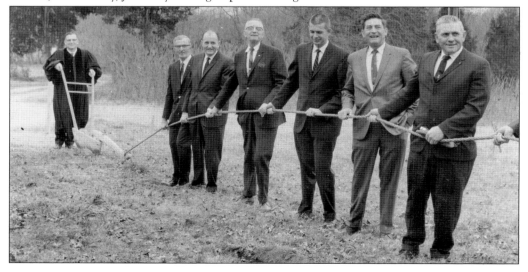

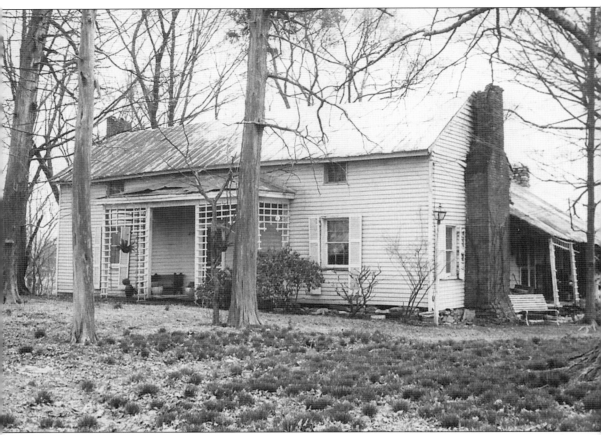

The Cloyd-Ligon property is one of the two oldest farms in Mt. Juliet. Pioneer Ezekiel Cloyd carved a trail to the area and, over time, he became land wealthy. Cloyd became a Presbyterian minister in 1795, helping to establish Stoner's Creek Presbyterian Church in Mt. Juliet, the first Presbyterian church in the area.

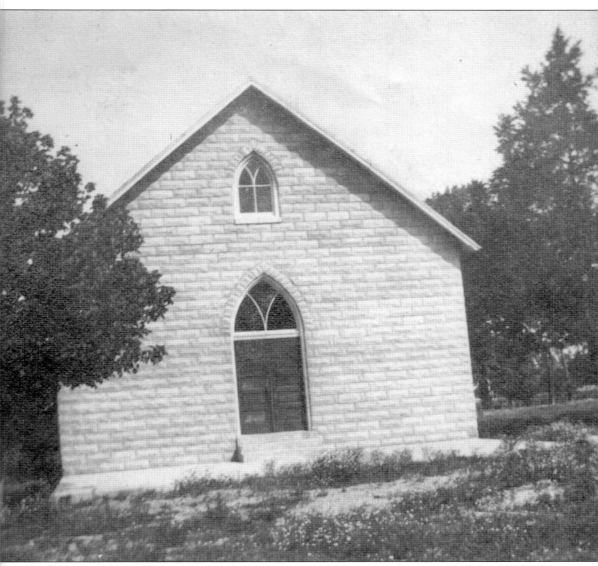

The beginning of the Mt. Juliet Church of Christ is estimated to be a few years before 1899, the year the deed for the original plot was signed. John E. Ridley held the first meeting in the fall of 1892. Tragedy struck on March 22, 1908, when a strong south wind and sparks from a nearby sawmill ignited the wood shingles of the one-room structure. Worshippers met in the old school building until a new church was finished. In 1946, Ray Jerkins became the first regular preacher for the congregation. For a time, baptismal services were held at the old "Baptizing Hole" on the Tilghman property, located on the current East Division Street. This photograph shows the rear of the old church.

Corona First Baptist Church was established in 1936, with Rev. Gilbert Bryant as the first pastor in the pulpit. Church members would bring coal and kindling from their homes to build a fire in the potbelly stove, and kerosene lamps provided light. A new structure with modern conveniences was erected in 1970.

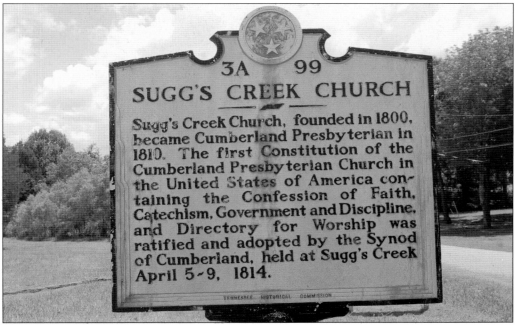

Rev. Samuel Donnell organized Sugg's Creek Church as a Presbyterian body in 1798. On this consecrated ground, the first constitution of the Cumberland Presbyterian Church in America containing the Confession of Faith, Catechism, Government and Discipline and Directory for Worship was ratified and adopted by the Synod of Cumberland on April 5–9, 1814. The first church house was made from oak logs in 1800 and replaced by a new cedar-log house in 1834. Pictured is the national historic marker located at the newest Sugg's Creek building.

The Williamson Chapel community is the oldest black community in West Wilson County. It is now known as the Needmore community. The name is said to have derived from a bachelor who thought the area needed more female prospects for dating. Pictured here is the Methodist church that African American Richard Williamson built in 1850 on land donated by slave owner Dick Mastaman. It also doubled as a school. The building burned down and was rebuilt in 1896, but the original floor joists remain today.

One of Mt. Juliet's land-wealthy families, the Williamsons, gave property to the African Methodist Episcopal (AME) Church to build a black church in the community. Black communities developed in areas like Mt. Juliet around churches and schools. As years passed, they were able to purchase farms throughout the Mt. Juliet area.

Pictured here is Beulah Bell, a longtime Sunday school teacher at First Baptist Church. For seven decades, this studious Christian lady taught people about the Bible.

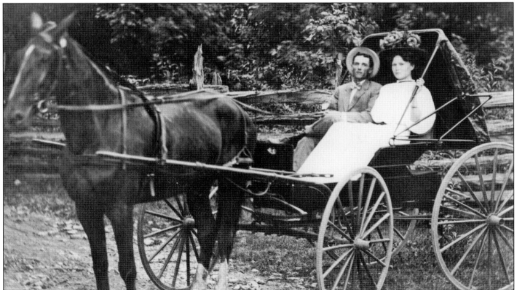

Edgar Allen Graves takes his newlywed sweetheart, Mama Essie Philpot Graves ,on a buddy ride, perhaps to one of their regular stops at church. This picture was made in the spring of 1909. The couple married on December 22, 1908. Graves was a well-dressed farmer who had one of the best-looking horses in the community, while his wife was known as a great equestrian who usually rode side-saddle.

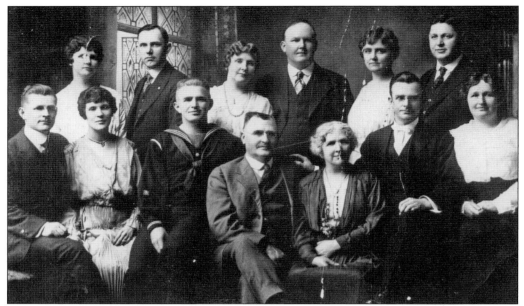

The Cawthons are one of the earliest families to live in original Mt. Juliet. Herschel Pierce Cawthon and Margaret "Maggie" Hibbett sit on the front row. From left to right are (second row) Rufus Vester Cawthon and Doving Bolling Talbot, Ollie Cawthon, Nona Belle Cawthon, and William Henry Cox; (third row) Dannie Cawthon and Andrew Wilson McCartney III, Dezzie Ezell Cawthon and Brownie Elise Adams, Pallie Cawthon and Watt Hamblen, and Herschel Meacham Cawthon and Helen McCartney.

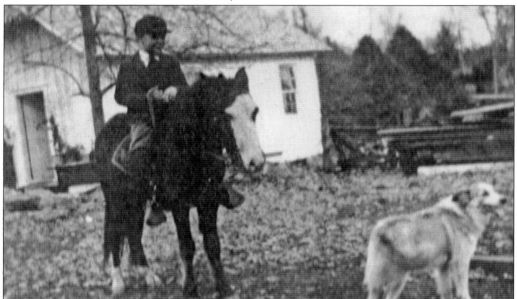

This is Grafton Graves, the father of Donna Graves Ferrell, one of the pivotal historians with the West Wilson Historical Society. Born in 1910, Graves, who was about age 10, is decked out in his riding clothes, sitting on his pony, Dixie.

This is a photograph of Annie Grigg, the wife of early entrepreneur J.W. Grigg. Annie was said to be a strong-willed woman who helped to keep the community's spirits high.

Margaret Everette Hibbett, who was known as "Honey" to friends and family, was described as an easygoing and loving person. Behind her shoulder is where the present city hall (below) now stands.

Jimmy Tate's grandfather, "Pa," and his wife, Glasgow, posed for this formal photograph. The Tate family owns one of the 100-year-old farms in the city. Zachariah Tate bought the 135 acres in 1810. One of his sons added 172 acres to the property a few years later. The next-generation owner, William Tate, was a captain in the Confederacy and served under Gen. Robert E. Lee.

Founded by Joseph Henry Rieff in 1801, the Rieff Land Farm (above) is more than 200 years old. The original owner was an important early Tennessee builder who helped build Pres. Andrew Jackson's plantation home, the Hermitage. Today, the 170-acre spread specializes in cattle and hay production. The farm's 19th-century log corn cribs (below) are used for storage.

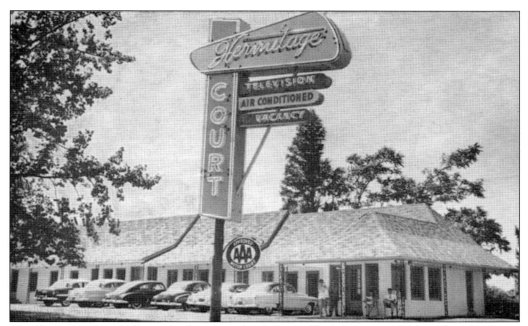

The Hermitage Motor Court, built and run by Anne and Jack Spence, was located in the Green Hill community near the Wilson County line. Shown here is one of the motel's postcards. Tourists checking out Pres. Andrew Jackson's home would stop for an evening's rest and a plunge in the pool.

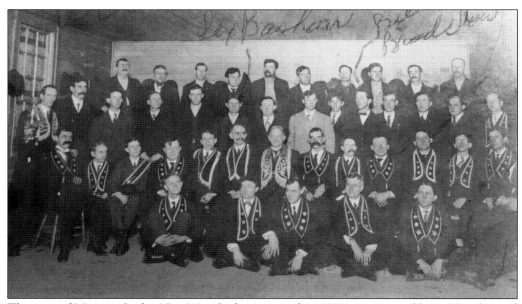

The men of Masonic Lodge No. 642, which originated in 1908, are pictured here. Now located on Tate Lane, the Mt. Juliet chapter has moved often during its 105-year history in town. Among its homes was the second story of the former Bank of Mt. Juliet building.

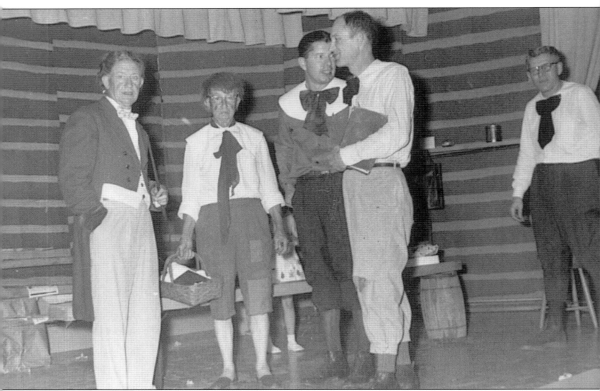

To be or not to be! Casting aside their farming or other job duties for the day, some adults would step into a more leisurely role. Many adult plays were held at the elementary school in town. The local thespians pictured here are, from left to right, Jack Gifford, Joe Falkner, Macon Castleman, Humphrey McCorkle, and Travis Garrett. The name of the play being produced here is *The Old District School*.

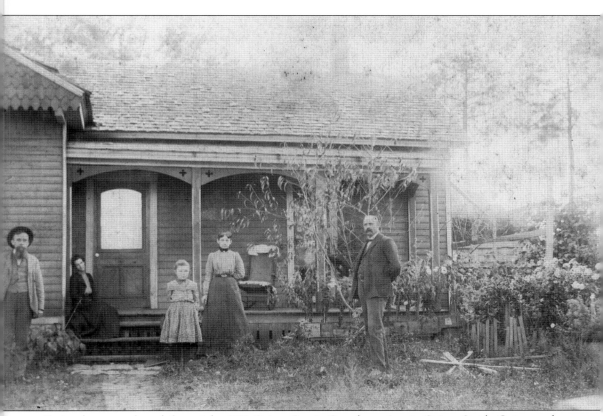

Posing here are, from left to right, J.W. Grigg, Carrie Cawthon, Annie Grigg, Quida Grigg, and J.W. Finney. This is the Grigg home, which was located where HLS Inc. Consulting Engineers operates today. The home was built as a section house by the Tennessee & Pacific Railroad.

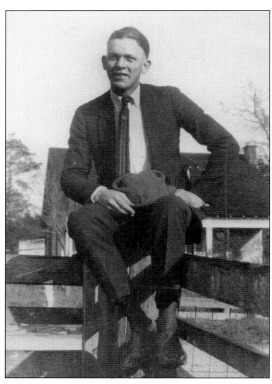

N.C. (Neland Carver) Hibbett, the father of Mt. Juliet's first mayor, sits on a fence in front of the house that his father built. A tornado swept the home away in the early 1900s.

This photograph of Frank M. Cawthon with his children and grandchildren dates to 1895. Cawthon was a lifelong farmer.

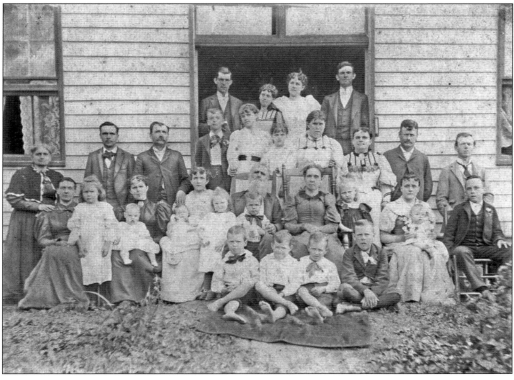

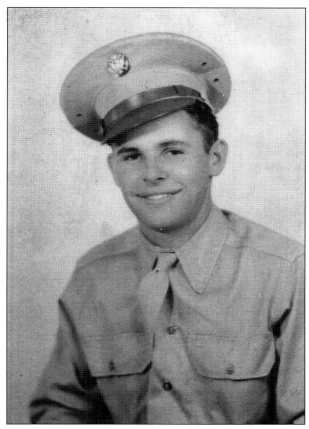

Pfc. William Edsel Wright, the son of Mr. and Mrs. John E. Wright, was killed on June 19, 1945, when a P-51 Mustang airplane crashed into the machine-gun emplacement that he manned. Wright was buried with full military honors in a Marine cemetery on Iwo Jima Island. "He stands in the unbroken line of patriots who have dared to die that freedom might live, and grow, and increase its blessings," Pres. Harry Truman wrote. "Freedom lives, and through it, he lives in a way that humbles the undertakings of most men." The American Legion dedicated a new bridge at Suggs Creek in his memory. Wright was one of 20 Wilson County soldiers in Battery C, 483 Anti-Aircraft Battalion.

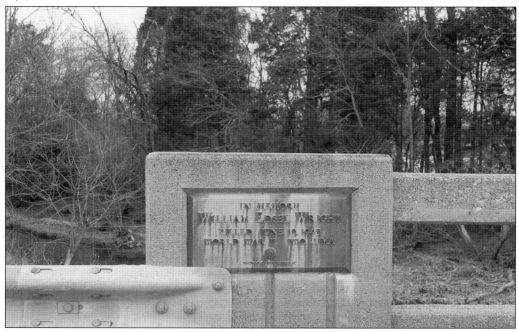

Pvt. William V. Smithson (1922–1944) died serving his country a month before Christmas. A member of Company I, 18th Infantry, he was wounded in action in the vicinity of Heistern, Germany. Private Smithson (right) was a rifleman participating in an attack on an enemy-held town. As the company advanced, it was met with concentrated enemy artillery and mortar fire. His brother, Winfield T. Smithson (left), received a Bronze Star when he was wounded in action.

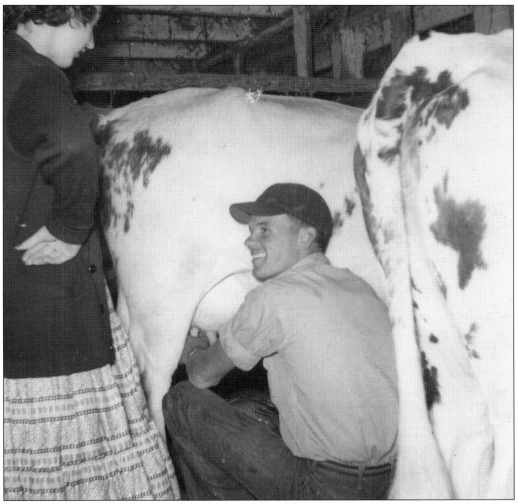

Taking care of one aspect of daily farm work, Gilbert Graves milks the cow. Mary Lou looks on.

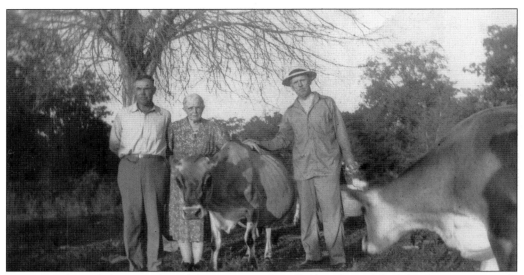

Circe Cawthon Philpot stands with her two sons, Ezra (left) and Virgil (right). This picture, made around 1940, was taken on the Philpots' 200-acre farm.

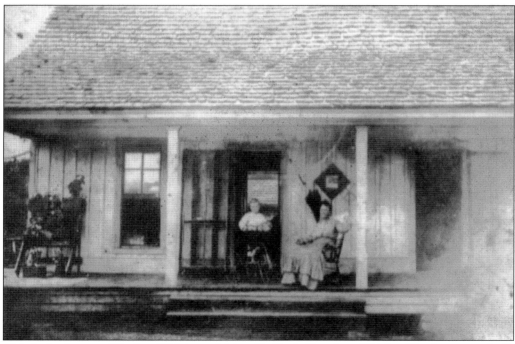

This is the home of Dr. Lee Wright and his wife, Ruth Cawthon Wright. The home was built about 1898 on Central Pike. Wright Farms Subdivision now stands on this property.

With this ring, I thee wed. Local business leaders were on hand as vows were exchanged at the wedding of Joyce Rummage. Pictured are Sam Everett, Les Hardaway, Bob Rummage, Melvin Everett, Fred Goodall, Neland Hibbett Sr., Rollie Peek, Charles Yelton, Elmer Curd, Hilton Tubb, and Jack Gifford. This picture was taken on September 4, 1948, in Madison, Tennessee.

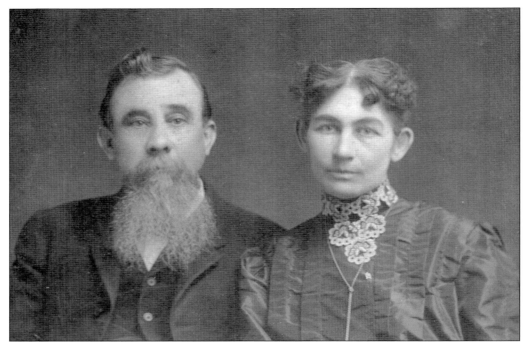

Mr. and Mrs. Jim Grigg were two of the prominent people in the town's early days. In addition to his business ventures, Jim Grigg was instrumental in raising the money for the Mt. Juliet Church of Christ. When the original structure caught fire, Annie Grigg rushed to try to save the contents. She made it out with the goblets but nearly lost her life in the act.

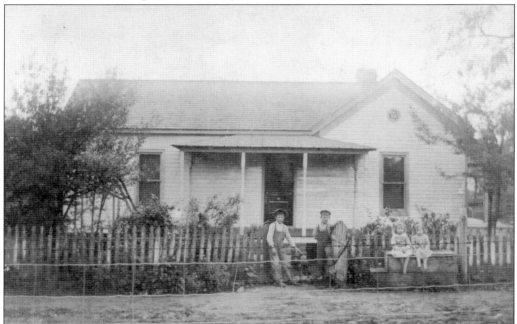

This 1904 photograph shows the Thomas L. Willis home. Pictured here are, from left to right, Frank Willis, Lynne Willis, Kathrine Willis, and Gwendolyne Willis.

Students were dismissed from class for an hour to begin celebrating the upcoming homecoming event at the Mt. Juliet High School football game on Friday night. Those that drove to school could fill their cars with fellow students and drive through town blowing their horns. Those without cars marched in single file around town, making as much noise as possible. (Courtesy Castleman family archives.)

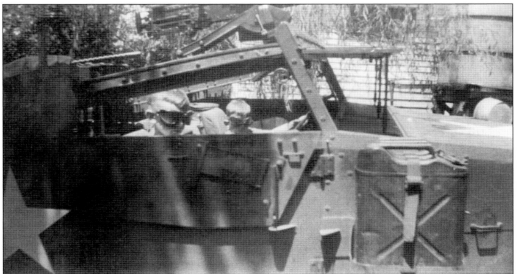

Soldiers practiced for the real war on home turf in places like Mt. Juliet. Soldiers would divide into two teams, the Red Army and the Blue Army, and would fire blanks at each other in war games. An officer with a white armband would make the deciding call on who won the simulated battle. In the summer of 1943, two boys witnessed the war maneuvers in person. In exchange for a delicious home-cooked meal, brothers N.C. and Truman Hibbett were allowed to hop aboard this half-track military vehicle for a photograph. Their mother often cooked for the hard-working troops.

Elwyn Weston gave a part of himself to save the life of a lost child. Hunting for the kid at a cold location in the north, Weston's legs froze, and as a result, doctors were forced to amputate both limbs below the knee. In addition to his act of heroism, Weston demonstrated his comedic bent. Once, he pulled a prank on two boys whom he had hooking up electricity. He signaled quietly to his buddy to watch as the two guys jumped when he hit the on switch. The men were fine, but a little shocked. On another occasion, Weston volunteered to stay up all night at the funeral home to keep watch over the corpses in exchange for a bottle of whiskey. The next morning, one body was drunk and another was propped up in the corner with a cigar in its mouth. Weston is pictured here with Carrie Cawthon (left) and Annie Grigg. Cawthon remained unmarried all her life after the love of her life died of pneumonia while serving during the Spanish-American War. She never accepted a date from another man.

With 450 acres, the Curd family had one of the area's most prestigious and prosperous farms. In the 1800s, Dr. J.N. Curd, a surgeon in the Civil War who later practiced in Mt. Juliet, held the reins of the farm. It was known for its prime livestock. Pictured here are Edgar Curd and his horse, Buster.

This is the Scobey-Ward family home. Their house was one of the many that also doubled as a hotel for temporary boarders from Nashville. People from Nashville would ride into town on the weekends to see the Saturday horse races at the Tighlman Stables and Race Track and then stick around for a baseball game on Sunday.

Eleanor Burnett and Woodrow Baird (front) exchanged "I do's" on November 24, 1948. They're posing here with their wedding guests, including Myra Burnett (second from left), who was a basketball stand-out in high school and a strong supporter of the Golden Bears all her life

Mama Philpot loved spending time with her grandchildren at her home on Central Pike.

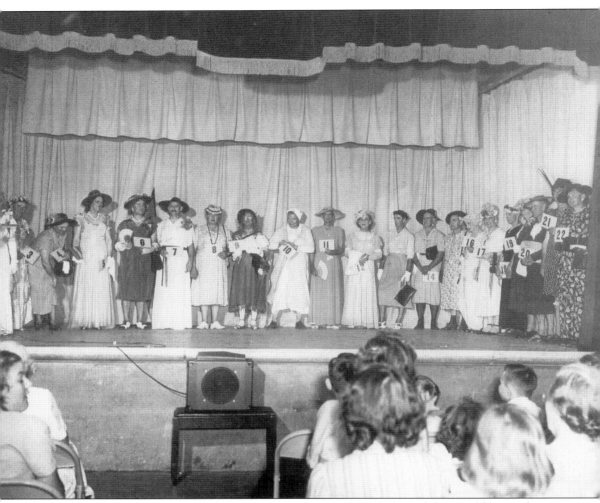

Look at those hairy legs! Members of the Mt. Juliet Men's Club showed they could be good sports with a fundraiser for the Mt. Juliet Athletic Association. It was billed as the "Men's Beauty Show." Guys dressed in ladies' attire, including evening dresses, street dresses, playsuits, and rompers. One of the participants, John Curd, decked out as Miss Cuddles for the night.

In 1801, early settler Blake Rutland established one of the rare 200-year-old family farms. Rutland, his wife, Martha "Patsy" Watson, and their nine children raised wheat, corn, and cattle on the 640-acre farm. Later, Woodrow and Eleanor Baird lived on the land in this home (right) built around 1900 by Herschel P. Cawthon. The below photograph shows the epitaph of the late community leader. He founded the Rutland community before Mt. Juliet came into existence. Rutland also donated land for the Rutland Baptist Church, the Rutland School, and the Colored Rutland School. Today, a road is named in his honor.

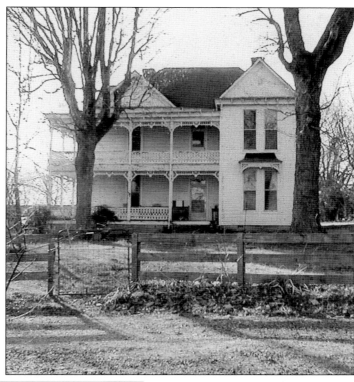

Alford's Camp Ground and Murray's Chapel consolidated to form Pleasant Grove United Methodist Church. Early settler Hollis Wright donated land to erect a sanctuary in 1870. A year later, the religious body met at Pleasant Grove Society. The church still stands on Central Pike.

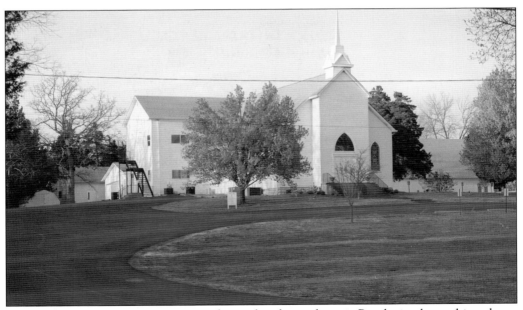

At first, the congregants sang praises and prayed in the outdoor air. People simply worshipped on a plot of land donated by the Cook family. Saints and sinners gathered under a brush arbor on the hill to hear evangelists preach the gospel. Cook's United Methodist Church was officially established by 1850. Congregants gathered in a one-room building furnished with hard, straight-backed chairs. In 1898, the second church opened with timbers that had framed the old building.

Five

SIMPLE LIVING

Jenny Bess Hibbett, the wife of Mt. Juliet's first mayor, N.C. Hibbett, played an important part in the early days of the city's government. She was the third mayor and first female mayor of the town after serving as a commissioner. A kindergarten teacher in the late 1950s, Hibbett helped start Mt. Juliet Christian Academy in 1961. She also has starred as Mother Goose, reading to children of the community as part of her job at the public library. The Hibbetts have three children, Bobby, Johnny, and Tommy, and five grandchildren. (Courtesy Mt. Juliet Library.)

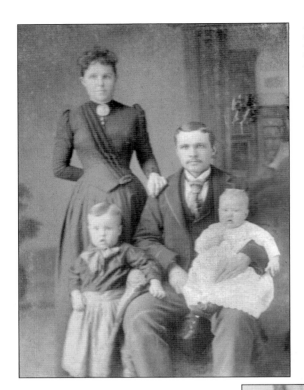

Lee and Circe Philpot are pictured here with their children Ezra (right) and Essie (left).

Irene Bates worked for the telephone company at a time long before cellular phones. She learned to operate a switchboard when caller ID meant that other parties on the line could eavesdrop on a caller's conversations. Bates once lived in the train depot that would become the telephone office. Here, she is standing close to the town well, where businesspeople filled buckets of water to have on hand for their customers.

The Castleman family was one of the first in Mt. Juliet to own a television set. On weekends, mechanic Macon Castleman would take a set home from his garage, where he sold Zenith televisions. In this photograph from Christmas Day, 1950, the family is gathered in the front room of the two-room garage home with the table-model television. Shown here are, from left to right, Janice, Evalena, Bettye, and Ron Castleman. (Courtesy Castleman family archives.)

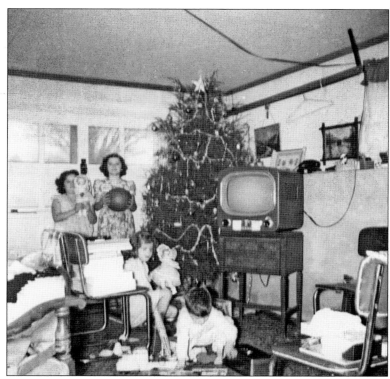

Shown here leaning against a tree is Clarence Bond. He was a school-bus driver and barber.

John Bell Viverette stands in front of the bus that he drove during World War II. People who worked in Nashville and Donelson would ride the commuter bus into work and back home.

J.W. Grigg had the only business in the village for a period of time. Grigg worked in several capacities, including as a druggist, ticket agent for the railroad, and operator of a post office. A skilled chicken breeder, Grigg became famous for his special barred rock strain.

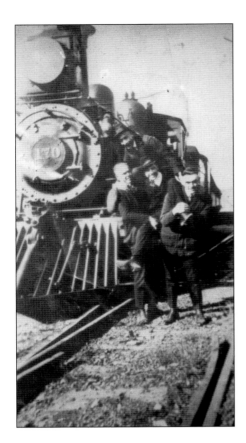

A.A. "Dick" Alexander, John Curd, and Willie B. Jennings mug for the camera in front of a train's front car. Alexander ran a grocery store with Clyde Gibson. Curd's family was one of the early taxpayers in the Rutland settlement.

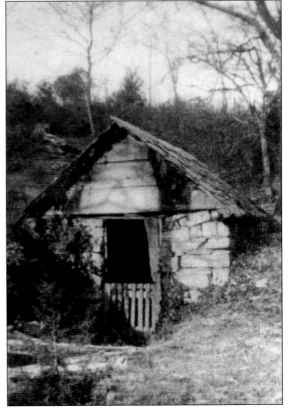

No matter how dry conditions were, the Falkner well house always had spring water running out of it. In fact, that was one of the reasons the Union army camped in the area during the Civil War. Soldiers were stationed on the road where the stagecoaches would drive before their march into Murfreesboro for the Battle of Stones River. The well sat on Joseph and Donna Falkner's property. She loved to entertain, and dinner guests knew that if they replied to her RSVP, they would not leave her home without a full stomach.

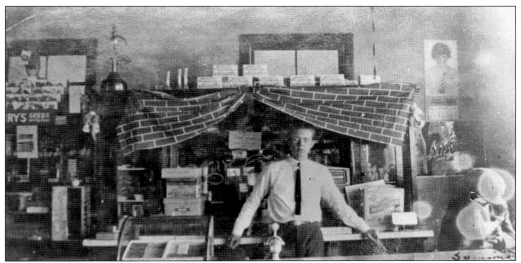

Courtney Johnson was one of the soda jerks at Hamblen Pharmacy. The scar on his face came from an accident with a soda bottle. Johnson was storing Cokes, a new product at the time, into boxes with ice when one of the glass bottles blew up and cut him in the face.

Perry Burnett was considered one of the strongest men in the county. He could hoist 100-pound sacks and plop them into wagons without breaking a sweat. In the 1930s, Burnett, of Mt. Juliet, was elected sheriff of Wilson County, a position he served for one four-year term.

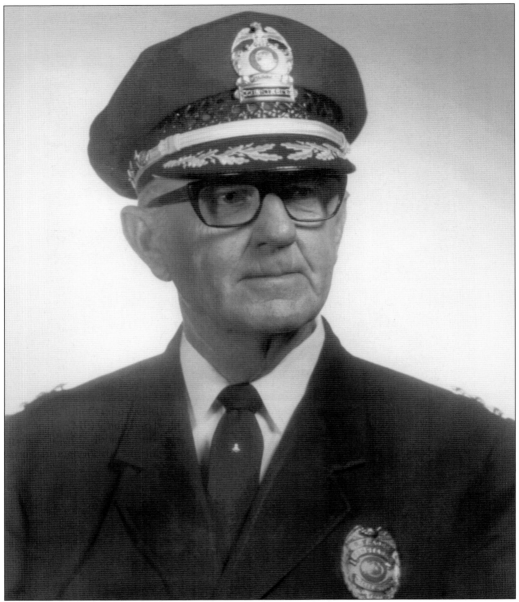

Formal security started in 1972. Buell Agee served as the city's first police chief for the next four years, until 1976. (Courtesy Mt. Juliet Police Department.)

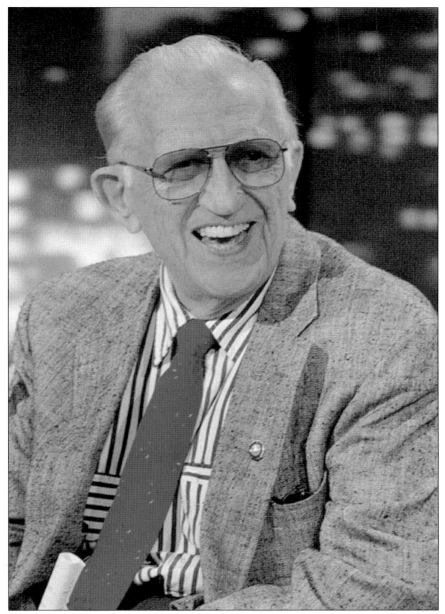

After years of successful production work on Music Row in Nashville, Country Music Hall of Fame producer Owen Bradley converted his old barn on Bender's Ferry into a recording studio in 1965. Conway Twitty and Loretta Lynn, Gordon Lightfoot, Joan Baez, the Beau Brummels, and other pop acts, along with dozens of country artists, recorded there. Bradley, the former head of Decca Records, is considered one of the architects of the Nashville Sound. During his illustrious career, he worked behind the control board for legendary ladies of country Patsy Cline, Brenda Lee, and Kitty Wells, among countless other musicians from a variety of genres. Bradley also produced the Academy Award–nominated sound track to the 1980 movie *Coal Miner's Daughter*. His first production smash was Red Foley's 1950 million-seller "Chattanoogie Shoe Shine Boy," which skyrocketed to the top of both the country and pop charts. (Courtesy Alan Mayor.)

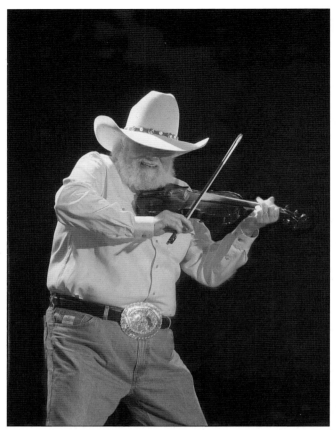

When musicians live close to the mecca of country music, they usually claim Nashville as their home, even if they live on the outskirts. Not Charlie Daniels. The iconic entertainer proudly proclaims Mt. Juliet, Tennessee, as his homestead. The Charlie Daniels Band is known for the Grammy-winning "Devil Went Down to Georgia," as well as "In America," "Mississippi," "Long-Haired Country Boy," and "The South's Gonna Do It." In 1998, he was honored with the Academy of Country Music's prestigious Pioneer Award for his tremendous contributions to music. Daniels has recorded with a diverse group of artists, including Bob Dylan, Flatt & Scruggs, Mark O'Connor, Leonard Cohen, and Ringo Starr. In the center of the city, Charlie Daniels Park (below), named in his honor, hosts numerous community events. (Left, courtesy Charlie Daniels.)

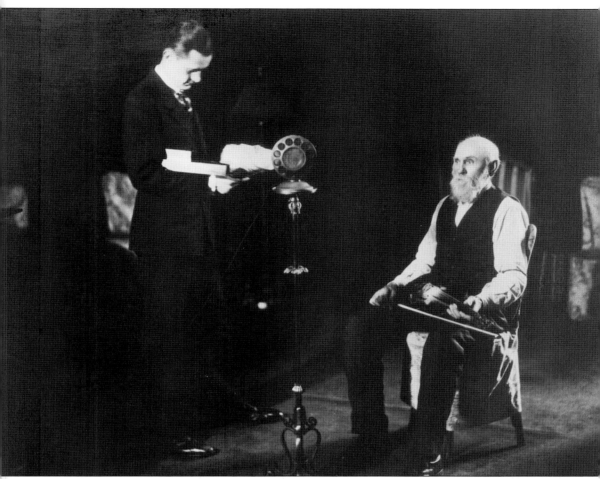

Colorful character Uncle Jimmy Thompson was said to have been the first player at the Grand Ole Opry. While that information is debatable, the famed fiddler is certainly the one who put the longest-running live radio show on the map. Sitting in a comfortable chair in front of an old carbon microphone, Jesse Donald "Uncle Jimmy" Thompson made his debut on the Opry for a solid hour on the night of November 28, 1925. WSM station manager George D. Hay finally ended the performance, asking Thompson if he was tired. "Why, shucks, a man don't get warmed up in an hour," the white-bearded 77-year-old Thompson replied. Thompson is buried in a cemetery near the LaGuardo Church of Christ off of Highway 109. He is pictured here in a publicity photograph with Hay. The joke-telling, jug-sharing musician owned a farmhouse in the LaGuardo community. (Courtesy Grand Ole Opry Archives.)

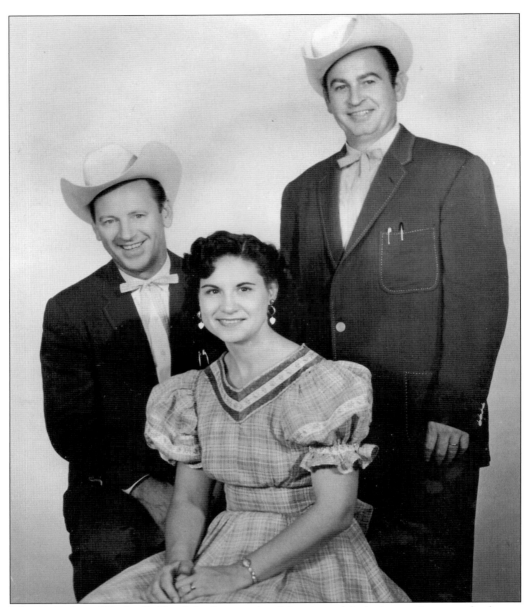

Johnnie Robert Wright (left), of the famous duo Johnnie and Jack, is a native son who began honing his musical chops at his home in West Wilson County. In 1935, he tried his hand at the music business in Nashville, where he met and married Ellen Muriel Deason, who later became the Queen of Country Music, Kitty Wells. A Grand Ole Opry member, Wright had a 1965 hit with "Hello Vietnam." Wells was the "girl singer" with Wright and his brother-in-law, Jack Anglin (right), in the 1940s. She became a star in her own right with the 1952 recording of "It Wasn't God Who Made Honky Tonk Angels." She had been persuaded to record the answer song to Hank Thompson's popular "The Wild Side of Life." The single sold more than 800,000 copies in its initial release. In 1976, Wells was elected to the Country Music Hall of Fame, and in 1991, she became the first female to receive a Grammy Lifetime Achievement Award. (Courtesy WSM Grand Ole Opry.)

This is a photograph of the Hamblen clan. W.W. Hamblen was one of the chief movers and shakers in the business community when the village of Mt. Juliet was beginning to take shape. Hamblen is pictured with his wife, Pellie Cawthon Hamblen, and their daughters, Mary Margaret (left) and Matty Terry (right).

Looking like a regal general, Frank Cawthon poses for this picture, which was made about 1918. Cawthon, who was the great-grandson of Blake Rutland, one of Mt. Juliet's earliest pioneers, lived to age 83. Hundreds of his descendants still live in the area.

Six

MODERN-DAY MT. JULIET

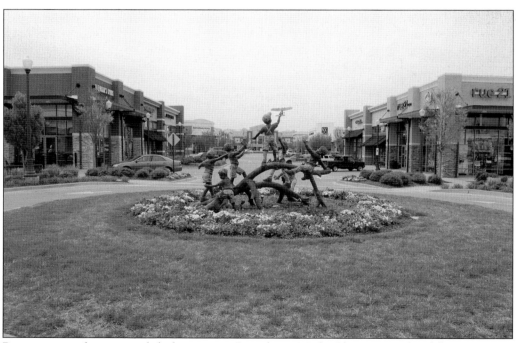

Restaurants and movies and clothing stores! Providence MarketPlace is one of Middle Tennessee's shopping meccas. This popular destination is 830,000 square feet of retail space, anchored by Target, JC Penney, Belk, Kroger, Providence Cinemas, Joann Fabrics, Dick's Sporting Goods, PetsMart, Old Navy, Chick-Fil-A, and Logan's Roadhouse.

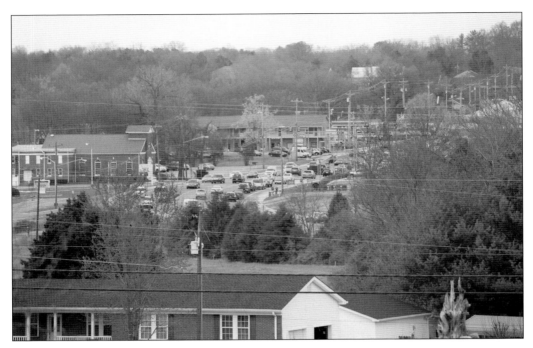

From a village with a one-lane dirt road to a city with a four-lane highway, Mt. Juliet is busting at the seams, with a population exceeding 25,000. The formerly quaint village is now a progressive suburb with plenty of residential transplants from all over the nation. The above photograph of the town was taken from the Stewarts' home, pictured below on the original mount of Mt. Juliet on Old Lebanon Dirt Road across the street from Wilson Bank & Trust Company.

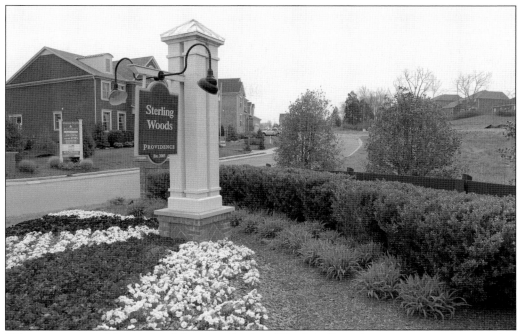

What is now a sparkling new subdivision, Sterling Woods in Providence, was once the stamping ground for chickens. Melzurie Ann Hewgley, wife of F.M. Cawthon, is pictured below feeding chickens. Back in the day, women would feed chickens to earn egg money, which would pay for household essentials. The expression "chicken feed," which means an insignificant amount of money, originated in the early 1800s. It alluded to the fact that chickens can be fed wheat grains and corn too small for other uses.

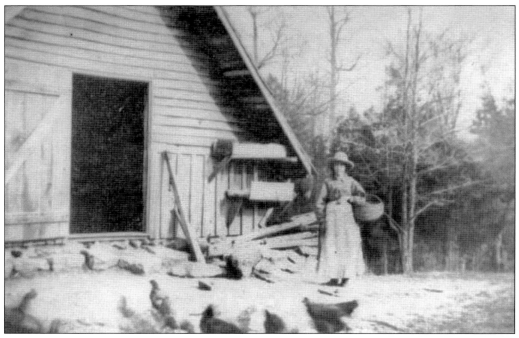

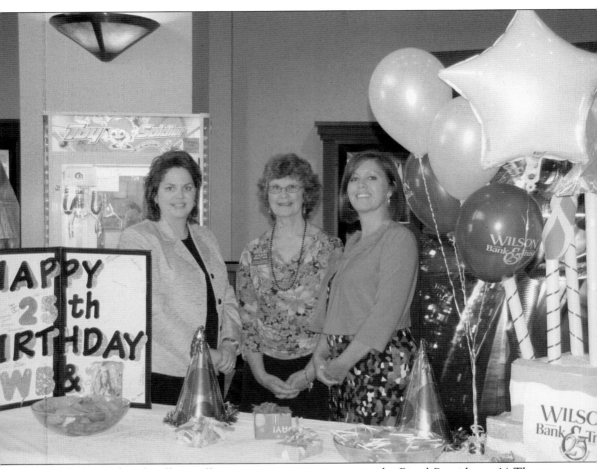

Digital sound and wall-to-wall screens attract moviegoers to the Regal Providence 14 Theatre. With its state-of-the-art stadium seating, the luxury theater is a popular spot in the city. Each summer, kids pile in for $1 reruns of family-friendly films. Wilson Bank & Trust, which sponsors the annual event, hosted its 25th anniversary party at the theater. Pictured here at the bank's celebration are, from left to right, Jennifer Medlin, Sheila Grewing, and Veronica Page. (Courtesy Wilson Bank & Trust.)

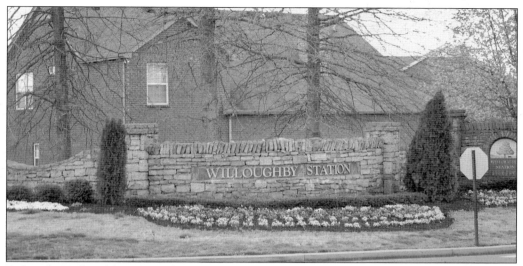

Before the Willoughbys, the Williamson family owned the property. In the midst of all the modern houses in Willoughby Station and a stone's throw away from the community playground is a cemetery where Revolutionary War patriot John Williamson (1764–1829) and some of his family members are buried. Williamson lived in the Wautauga District (now east Tennessee) as part of a group of "hard-working independent minded yeomen farmers." The Wautaugans, including John Williamson, became famous for successfully using guerrilla warfare tactics that they had learned in constant battles with the Indians to fight the British at the battle of King's Mountain, North Carolina. He was elected to the Tennessee House of Representatives and lived in Green Hill (now Willoughby Station), where he died. The Williamson pioneers and their descendants are listed among the "First Families of Tennessee" in recognition of their arrival in Tennessee prior to statehood in 1796.

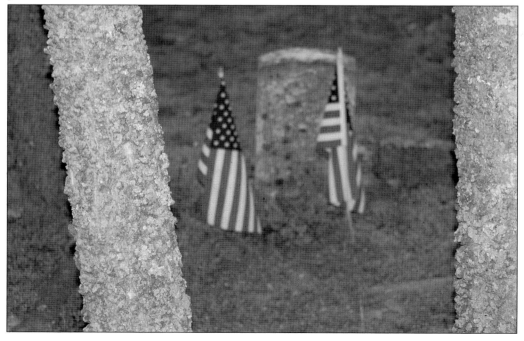

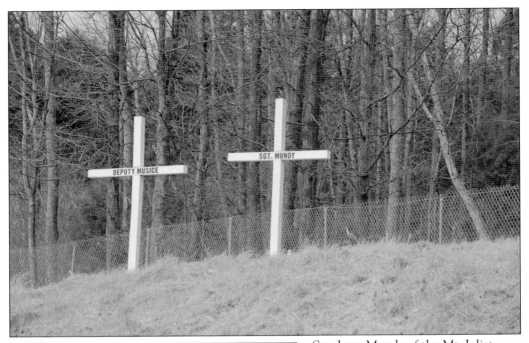

Sgt. Jerry Mundy of the Mt. Juliet Police Department and Wilson County sheriff's deputy Jon Musice were killed in the line of duty when the driver of a stolen car hit and killed them. The two officers had placed a spike strip across Interstate 40, hoping to bring the 30-minute high-speed chase to a safe end. The driver tried to avoid the spike and veered off the road, striking the two officers, who were waiting near their vehicles. The cross markers in this photograph stand as a memorial to Mt. Juliet's brave heroes.

Kenny Martin is the present and fourth city manager. Having served with the police department for 17 years, Martin became police chief in 2002. He held that position for four years. Prior to Martin, Danny Farmer, Rob Shearer, and Randy Robertson were the city managers.

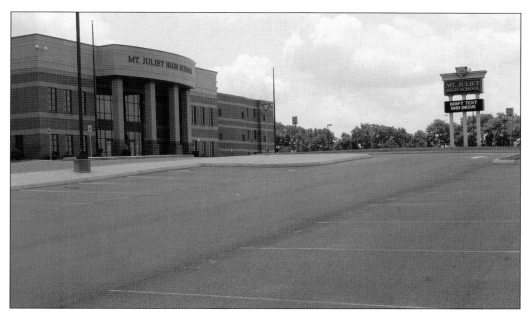

Mt. Juliet High School felt "bear pride" in 2011, when the Tennessee nonprofit State Collaborative on Reforming Education (SCORE) chose the school as the number one "academic school" in the state of Tennessee. SCORE selected Mt. Juliet High for "dramatically improving student achievement in spite of the challenges they face." The high school moved from its previous building on Mt. Juliet Road to Curd Road in 2008.

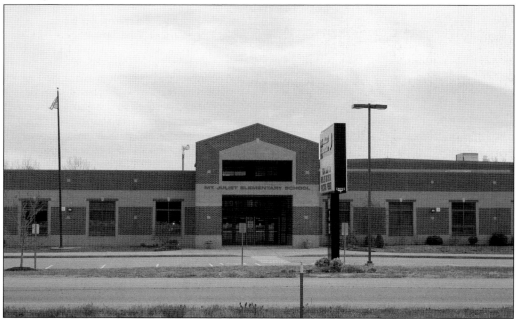

The Wilson County Commission voted in March 2003 to fund a new Mt. Juliet Elementary School. The school is located on West Division Street, only a few miles from the former school, at the corner of East Division Street and Mt. Juliet Road. It is one of 12 elementary schools in Wilson County.

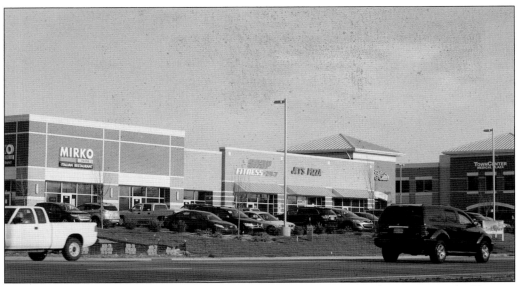

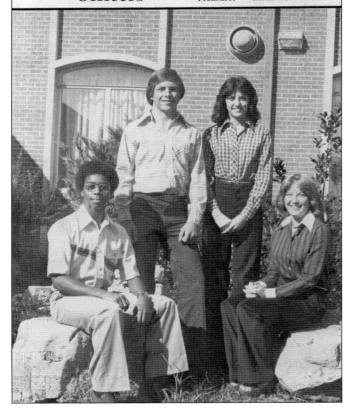

Junior Class Officers

President — Dale Wainwright
Vice President — Mike Maddux
Secretary — Becky Raymond
Treasurer — Mitzi Brown

New businesses in the Town Center Plaza occupy what once was the distinguished home of Mt. Juliet Elementary School. Who knows? Maybe some of the school's graduates could end up taking home a paycheck from Mirko Pasta, Jett's Pizza, Snap Fitness, or Bar-B-Cutie. In 1993, Mt. Juliet Elementary School became the second elementary school in Wilson County to be accredited by the Southern Association of Colleges and Schools. Today, it is a busy thoroughfare. (Courtesy Mt. Juliet High School.)

In 1978, Dale Wainwright became the first black valedictorian of Mt. Juliet High School. President of the junior class, Wainwright is the second African American elected to serve on the Texas Supreme Court. "That's not too bad for a country boy from a small town of 2,000 people," Wainwright said of his new role on Texas' highest civil court. (Courtesy Mt. Juliet High School.)

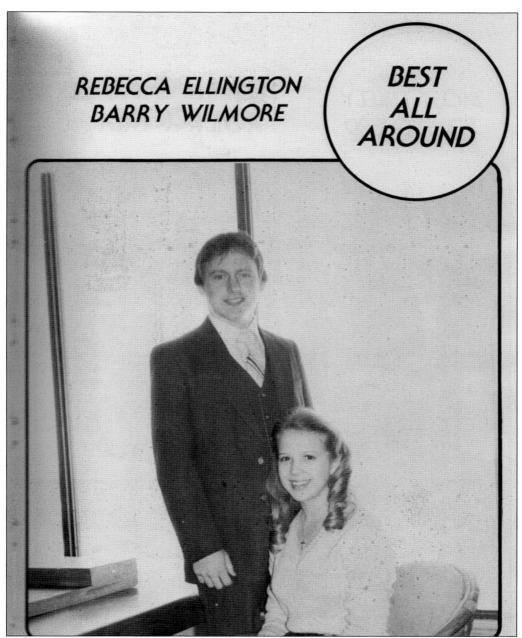

REBECCA ELLINGTON
BARRY WILMORE

BEST ALL AROUND

Mt. Juliet native Barry Wilmore is an astronaut for NASA. He was selected as a pilot in July 2000 and completed his first flight as a pilot on STS-129 on November 16–29, 2009. It was the 31st shuttle flight to the International Space Station. At Mt. Juliet High School, his classmates named him and Rebecca Ellington "Best All Around." (Courtesy Mt. Juliet High School.)

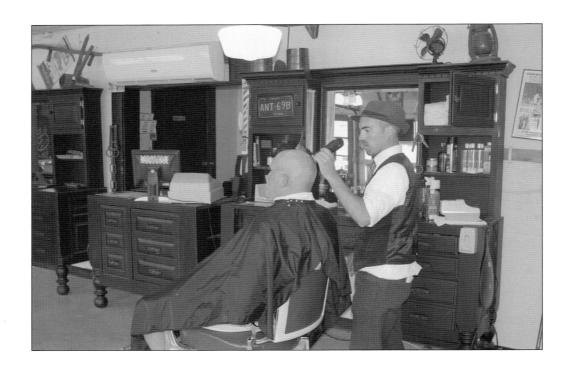

Take a little off the top! In the above photograph, John Martinez clips away on Bill Harbarger's hair at his City Limits Barber Shop on the outskirts of town. The rustic building used to be a drive-in market that Martinez's grandparents ran from the 1950s to the early 1990s. A few other businesses leased the space until John put his creativity into refurbishing the former grocery store. A large, old-fashioned barber's pole that Martinez made welcomes customers into the nostalgic world inside. With *Andy Griffith Show* reruns playing in the background, customers sit in the 1940s barber chair surrounded by yesteryear treasures like a rusty bucksaw, pitchforks, harnesses, and vintage pictures. In the below photograph are the original owners/operators, Ralph and Aileen Oldham, in front of Oldham's Drive In Market in the late 1950s. (Below, courtesy John Martinez.)

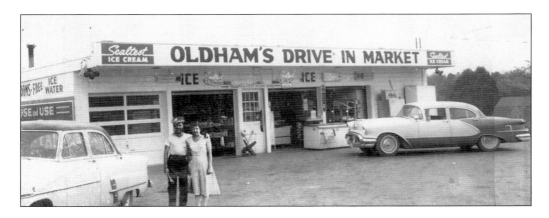

Garr's Equipment Rental and Feed was a family-owned hardware, feed, and rental store that served Mt. Juliet and Wilson County for over 27 years before closing in 2013. The store carried most everything a customer could need, and if it could not be hauled home, the store would deliver it. Its services include delivery and pick-up of feed and rental equipment, propane refills, pond installation, repair of small engines and lawn equipment, wildlife expertise, and much more. The company offered special events for families, including annual photographic visits with Santa Claus. Below, Old Saint Nick listens to what Gavin Conger wants for Christmas.

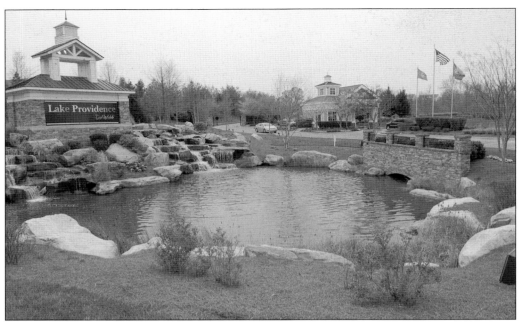

Some of the town's active older adults live at Lake Providence Del Webb. The luxurious living quarters includes a 24,000-square-foot clubhouse, an indoor and outdoor pool, a spa, and a 15-acre lake for fishing and paddleboats.

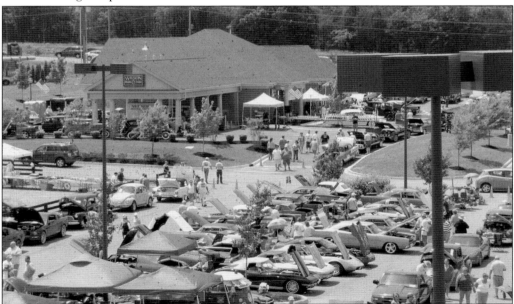

At one time, only one bank served the people of Mt. Juliet. Now, there are several throughout the city, including this branch office of locally owned Wilson Bank & Trust. The bank is located across the street from the first house in the original Mt. Juliet. Vehicles from an earlier era are showcased each year at the annual Antique Show Car Meet. The bank shows its interest in the community with various events, including the Ladies Day Fashion Show. (Courtesy Wilson Bank & Trust.)

Although the agrarian lifestyle has faded into the background in today's Mt. Juliet, there are still some farmers who make a go of it. Tomatoes, cucumbers, cherries, and strawberries are part of the staple of fresh crops the cultivators of the soil sell at the farmers market. The market operates May through November at Charlie Daniels Park. Pictured below are some of the peach trees coming into season at Breeden's Orchard on Beckwith Road. In the fall, apples are in bloom. Customers can pick their own fruit, watch apple cider being made, or visit the pie kitchen.

At Cedar Creek Sports Center, residents can smack line drives in the batting cages, tee off at the driving range, or putt around on the miniature golf course. The 16.5-acre facility has been offering family-friendly fun since 1991.

Mt. Juliet has become a bike-friendly town, with dedicated bike lanes an integral part of the road design throughout the city. The Veloteers Bike Club provides a "wheely" good time for those on steel wheels, from slow pokes to speedsters. Here, Dave Perrault waves during a Veloteers ride on Division Street. (Courtesy Veloteers Bike Club.)

Nicknamed the "City Between the Lakes," Mt. Juliet is in a prime spot for water recreation at Old Hickory Lake and Percy Priest Lake. One sport that is making waves is stand-up paddleboarding. Whether for fitness or as a scenic excursion, Adventure Paddle is expanding this Hawaiian sport in Middle Tennessee. Here, Marcie Murrell gets a little rest and relaxation at sunset.

DISCOVER THOUSANDS OF LOCAL HISTORY BOOKS FEATURING MILLIONS OF VINTAGE IMAGES

Arcadia Publishing, the leading local history publisher in the United States, is committed to making history accessible and meaningful through publishing books that celebrate and preserve the heritage of America's people and places.

Find more books like this at
www.arcadiapublishing.com

Search for your hometown history, your old stomping grounds, and even your favorite sports team.

Consistent with our mission to preserve history on a local level, this book was printed in South Carolina on American-made paper and manufactured entirely in the United States. Products carrying the accredited Forest Stewardship Council (FSC) label are printed on 100 percent FSC-certified paper.

MADE IN THE USA